CARGO

EXCAVATING THE CONTEMPORARY LEGACY
OF THE TRANSATLANTIC SLAVE TRADE
IN PLYMOUTH AND DEVON

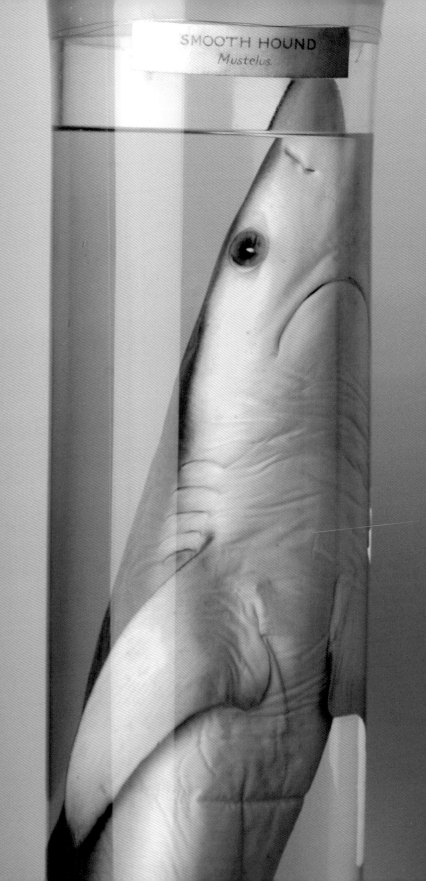

SMOOTH HOUND
Mustelus.

CARGO

EXCAVATING THE CONTEMPORARY LEGACY
OF THE TRANSATLANTIC SLAVE TRADE
IN PLYMOUTH AND DEVON

EDITED BY LEN POLE & ZOË SHEARMAN

University of Plymouth Press

Paperback edition first published in the United Kingdom in 2011 by University of Plymouth Press, Roland Levinsky Building, Drake Circus, Plymouth, Devon, PL4 8AA, United Kingdom.

ISBN 978-1-84102-268-0

A CIP catalogue record of this book is available from the British Library.

Edited by Len Pole and Zoë Shearman
Produced by Zoë Shearman assisted by Judith Robinson
Timeline researched and edited by Len Pole assisted by Tony Eccles and Emma Philip
Designed by Steven Bond and Daniel Jones for The Bridge Creative Agency
Additional Proofreading by Gavin Thomas
Printed and bound by R. Booth Limited, Penryn, Cornwall, UK
Distributed by NBN International, Plymouth, UK

Published to reflect on the exhibition *Human Cargo: The Transatlantic Slave Trade, its Abolition and Contemporary Legacies in Plymouth and Devon.*
Plymouth City Museum and Art Gallery, Drake Circus, Plymouth, PL4 8AJ, UK
www.plymouthmuseum.gov.uk
A partnership with the Royal Albert Memorial Museum & Art Gallery, Exeter, UK
22 September - 24 November 2007
Curated by Len Pole and Zoë Shearman
Artist-Advisor: Raimi Gbadamosi

Front and back endpapers
Lent Lily
Jyll Bradley with Claire Turner and George Hadley
Wallpaper design, 2007

Frontispiece image
Dogfish, a kind of shark.
Sharks followed ships used in the slave trade across the Atlantic, attracted by the ships' smell and the likelihood of dead or dying captive Africans being thrown overboard.
Late 19th century; Collection of Plymouth City Museum and Art Gallery.
Chosen by Raimi Gbadamosi for inclusion in *Human Cargo*

Contents

Foreword

This publication offers a critical framework for reflection upon the ideas raised by Plymouth City Museum and Art Gallery's exhibition marking the 200th anniversary of the Abolition of the Slave Trade, a partnership with The National Portrait Gallery and collections in Plymouth and Devon.

It sets out to 'excavate' the legacy of the Transatlantic Slave Trade as experienced today, starting from the contemporary art perspective and working backwards through history. As a parallel project to the Human Cargo exhibition, this book also brings together contemporary art and current museum practices to reflect upon the different histories of the Slave Trade within museum collections and our relationship to contemporary slavery through everyday consumerism.

The Human Cargo exhibition has been recognised by the Museums, Libraries and Archives Council, South West, as a flagship project for the Museum sector, as it created meaningful engagements between museum collections, their curators and contemporary artists.[1] Plymouth City Council has also recognised the contemporary art commissions as contributing to the City of Plymouth's successful renewal of its Fair Trade City status.

A number of partnerships underpinned the achievement of this complex project. In particular, the collaboration with the Royal Albert Memorial Museum & Art Gallery, Exeter, and specifically the support of Tony Eccles, Curator of Ethnography. Other key partners included Arnolfini, Bristol; BBC South West; Plymouth Libraries; Plymouth and West Devon Record Office; Plymouth Arts Centre; Plymouth and West Devon Racial Equality Council; and the University of Plymouth.

Plymouth City Museum and Art Gallery is greatly indebted to the project funders: Arts Council England, Exeter City Council, the Department of Culture Media and Sport/ Department of Education National/Regional Strategic Commissioning Partnership Programme; the MLA's Designation Challenge Fund; the Renaissance in the Regions programme, and Plymouth City Council

The Museum also acknowledges the support of the institutions who lent work to the exhibition and all the individuals and organisations that contributed to the development and delivery of Human Cargo.

Much appreciation is due to the Human Cargo project lead, Judith Robinson, the exhibition curators and editors of this book, Len Pole and Zoë Shearman, the artist-advisor to the exhibition, Raimi Gbadamosi, and all the artists for their inspiration and commitment to the development of the project. Their involvement allowed the City Museum to challenge established conventions and to produce a remarkable and groundbreaking project.

The Museum is particularly grateful to the artists and writers for their contributions to this publication and to Paul Honeywill, director of the University of Plymouth Press, and designers Steven Bond and Daniel Jones of The Bridge for their partnership and facilitation of the production process. Thanks are also given to Jane Connarty, author of the Human Cargo Evaluation Report which is cited in a number of the texts.

This book and the Human Cargo exhibition have been important opportunities for the City Museum to reflect upon its own history as a public institution, its collections and its potential role in supporting understanding of complex histories through meaningful engagement with contemporary visual art.

Nicola Moyle
City Curator
Plymouth City Museum and Art Gallery

[1] Connarty, J. Human Cargo Evaluation Report: Executive Summary, (Plymouth City Museum and Art Gallery, 2009).

Introduction: Human Cargo in Context

In 2007, a national programme of events marked the 200th Anniversary of the 1807 Act of Abolition which made it illegal for British nationals to be involved in the Transatlantic Slave Trade. The official commemoration of this significant moment in British history presented a unique challenge to the museums sector in this country: the engagement of audiences with sensitive issues and uncomfortable truths surrounding the impact and legacy of the Slave Trade and its Abolition, including the acquisition of wealth and cultural property in Britain.

Plymouth City Museum and Art Gallery is a leading cultural institution in the context of Plymouth and Devon, an area with acknowledged but under researched connections to the Transatlantic Slave Trade and its Abolition.

The approach to Abolition 200 taken by Plymouth City Museum and Art Gallery was based on partnership and became an experimental collaboration between current museum, ethnographic and contemporary art curatorial practices. The direction and content of our project was informed by new research and a process of public consultation, and its development was shaped through extensive ongoing dialogue and critical reflection between Museum staff, the appointed curators – Len Pole, consultant ethnographer, and Zoë Shearman, independent contemporary art curator, artist-advisor, Raimi Gbadamosi, and the other invited artists. The role of Raimi Gbadamosi was crucial to the process of curatorial review, guiding the selection of material and graphic content, challenging assumptions and influencing the approach taken to the exhibition design and the tone of the presentation.

The primary aims established by the project team were to investigate, document and appraise the role of Plymouth and Devon in this complex period of world history; to reveal aspects of the different histories of slavery; to invite audiences to consider the museum as a site for these histories and reflect on the legacies that remain with us in public

TIMELINE OF SLAVERY

1440

1441
A Portuguese ship brings a cargo of African captives to Lisbon from Arguin on West African coast

1442

1443

1444

1445

1446

1447

1448

collections; to engage audiences in an understanding of their implication in contemporary slavery, and to explore parallels between the 18th century Abolitionists and the modern day Fair Trade movement. The overall intention of the City Museum was to raise awareness and understanding locally of the links between Plymouth and Devon and the Transatlantic Slave Trade and its Abolition.

The project that emerged was Human Cargo – The Transatlantic Slave Trade, its Abolition and Contemporary Legacies in Plymouth and Devon which comprised of a major multidisciplinary exhibition at Plymouth City Museum and Art Gallery from 22 September to 24 November 2007, a broad based education and outreach programme, and a number of collaborative initiatives.

The exhibition charted the existence of slavery from 1400 and highlighted the ways in which enslaved Africans and others fought to overcome oppression. Significantly, it also considered contemporary legacies of the Slave Trade, present-day forms of forced labour, and the implications of modern consumerism. Research based evidence was presented in the form of a graphic timeline, alongside ethnographic, natural history, art and archival material from local, regional and national public collections. It also featured context-led, socially engaged contemporary art commissions, including an artist's museum trail, by five artists/collectives working internationally – Jyll Bradley, Lisa Cheung + WESSIELING, Raimi Gbadamosi, Melanie Jackson and Fiona Kam Meadley. The art works were presented throughout the Museum building, intervening in the permanent collections on display, and were integrated with the historical material in the exhibition galleries.

The project evaluation report discusses this approach to the presentation:

"The resulting presentation allowed for the complexity of these histories and contemporary issues to be communicated effectively to the audience, and in such a way that leaves an openness that allows for questioning and personal interpretation." [1]

1449 1450 1451 1452 1453 1454 1455 1456 1457 1458 1459

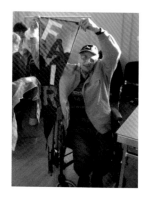

It also indicates the impact of the artists' interventions:

"...there was a consensus that the inclusion of commissioned artworks contributed significantly in highlighting contemporary legacies of the slave trade, including slave labour, human trafficking, exploitation of workers, and our own implication in these practices as consumers. The contemporary artworks powerfully located the project in the present, and offered a subjective space in which viewers might reflect on the continuing relevance of the histories of slavery and Abolition." [2]

The interpretation, education and outreach programmes were integral to the Human Cargo project and involved the Museum Learning and Community teams working with performance artists and commissioning participatory activity that engaged with communities and groups across the City of Plymouth. Artist, Lee Sass led a programme of activity with the Edith Freeman Day Centre and Scope, and a wide range of groups took part in Lisa Cheung + WESSIELING's Sweatshop both in and outside the Museum.

The Living Memory Lab was a collaborative Heritage Lottery Fund supported project led by the BBC South West that enabled people of Plymouth to produce films about the Transatlantic Slave Trade, its

— Above & Right

Sweatshop workshop, 2007
Lisa Cheung + WESSIELING

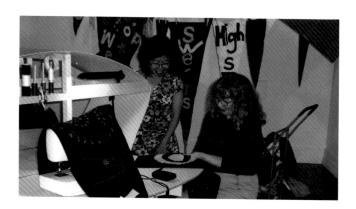

1460 1461 1462 1463 1464 1465 1466 1467 1468 1469

Abolition and legacy. A selection of these short films was screened in the exhibition resource area and they are now being used as a teaching aid and resource.

An outstanding legacy has been the comprehensive Human Cargo Education Pack produced by the Museum Learning team and distributed to all secondary schools in Plymouth and Devon. This formed part of a new Plymouth City Museum and Art Gallery Museum in Transit teaching resource which remains in constant demand from local schools. During the exhibition, the Learning team organised re-enactment sessions for school children at the Elizabethan House in Plymouth, part of the City Museums service, which gave children a greater understanding of the realities of the slave trade.

The project was viewed by many as a catalyst for enquiry and learning, and artists and other project participants commented in the evaluation that it:

"represented a valuable starting point for an ongoing process of enquiry and learning, both for themselves, audiences and museum staff."[3]

Human Cargo offers Plymouth City Museum and Art Gallery an opportunity to build on this foundation and continue a process of research and interrogation towards 2033, the anniversary of the Act of Abolition of Slavery throughout the British Empire.

Judith Robinson
Exhibitions Officer
Plymouth City Museum and Art Gallery

References

[1] Connarty, J. *Human Cargo Evaluation Report: Executive Summary* (Plymouth City Museum and Art Gallery, 2009)

[2] Ibid.

[3] Ibid.

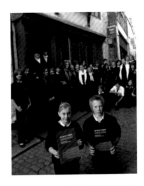

— Above

Kingsbridge Community College students visit Plymouth's Elizabethan House for a re-enactment session, and receive copies of the *Human Cargo* education pack

Student re-enactment of the transportation of African Slaves on the infamous 'Middle Passage' to the Americas. The Students remained in this position for over 20 minutes

1470

1471
The Portuguese establish contact with "the village of two parts" on the Gold Coast. This was the place known later as Elmina

1472

1473

1474
The Portuguese make first contact with the City of Benin in what is now Nigeria

1475

1476

1477

1478

Excavating the Present

Zoë Shearman

"He who seeks to approach his own buried past must conduct himself like a man digging" — Walter Benjamin[1]

This book and the related museum exhibition[2] each adopt two chronologies, one starting from the present and working backwards and the other starting from the past and moving towards the present. This approach is mindful of Michel Foucault who wrote that his historical investigations of the past were only the shadow cast by his theoretical interrogation of the present. It is on our ability to be contemporaries not only of the twenty first century and the 'now', but of the past, that our understanding depends.[3]

In contributing to both manifestations of this project, my interest has been to endeavour to be self-critical in asking the questions: "What does it mean to refer to the histories of the Slave Trade in the context of the Museum, through 'contemporary art?', 'What are the changing relations of the ethnography of the West with other societies?', What is the role of cultural institutions within artistic processes?', and 'What is the relationship between art and critical ethnographic practice?"

Thus, as curator, I invited four artists and one artist collective to develop interventions in the museum, as part of an exhibition which brought together contemporary art and current museum practices. In the context of the Museum and the wider social realm, the artists' projects reflected critically upon the different histories of the Slave Trade embodied within the institution and its collections, and our relationship to contemporary slavery through everyday consumerism. In so doing, the commissions made a number of references to the changing global conditions of trade and migration today, and the lasting effect of the Transatlantic Slave Trade as reproduced in contemporary culture. The artists' projects took

1479

1480
The Portuguese make contact with Loango in Central Africa

1481

1482
Diego da Azambuja receives permission to build a fortification at Elmina, after negotiations with Caramanca, the chief of the place

View of Elmina Castle, 1972

Cristoforo Columbas visits Elmina, while living in Madeira

place throughout the Museum's public spaces, and beyond, and were conceived in relation to the institution's audiences, collections and architecture. The artists' adopted context-led, participative and socially-engaged approaches, which were developed through a process of research and development that took place over one year.

The exhibition and this book reflect on the present and the past to begin a process of revealing the implication of the Museum, its collections, and publics (ourselves), in the different histories of the Slave Trade. This book is intended as a critical platform in its own right and to operate as a discursive space. It adopts the framework of 'excavating' the contemporary legacy of the Transatlantic Slave Trade as experienced today, starting from the contemporary art perspective and working backwards through history. This 'archaeological' approach is set against a more traditional linear chronology that runs through the book in the form of a timeline of the Slave Trade from 1400 to the present day. The intention is that these two chronologies function as a useful tool with which to reflect upon the histories of the Slave Trade; the reciprocal relationships between times and cultures; and the legacies of the past in the present.

The deliberate dis-'orientation'[4] of this book's structure reflects current ethnography and the new 'spatial practices',[5] new forms of dwelling and circulating. This and the last century have seen a drastic expansion of mobility in which difference is now encountered in the adjoining neighbourhood and the familiar turns up at the end of the earth. Consequently, a whole structure of expectations about authenticity in culture and in art is thrown in doubt. This approach is a condition of being in a culture whilst looking at culture and a response to the twenty first century's unprecedented overlay of traditions. A contemporary 'ethnography' can be understood as constantly moving between cultures, it is perpetually displaced.

1483

1484
Portuguese reach Damaraland
in what is now Namibia

1485

1486
Sugar plantations are
established on SaoTome Island,
worked by slaves owned by
the Portuguese

1487

1488

1489

1490

1491

1492

The Shadow of Things

In writing this outside in the sunlight, the text and my reflection are superimposed on the screen of the laptop. In adjusting my position to follow the sun's movement, the reflection changes. While the 'figure' of the text is fixed, the 'ground' of the reflection is transitory. Similarly, while the material objects in museum collections remain, their contexts have changed, been forgotten, or 'disappeared'. However, as Foucault analysed, the present is constructed through a continuation of all the genealogies of history: *The Archaeology of Knowledge*.[6]

The motto above Aby Warburg's library in Hamburg[7] was simply 'Mnemosyne', memory. He developed a way of looking at philosophy, science and art that excluded nothing: not astrology, nor alchemy, nor magic, nor any of the aspects of the past that modernity had relegated to the bin of intellectual dead ends. So each floor of the current Warburg Institute library has its own theme: basement and first floor, Image; second floor, Word; third floor, Orientation; fourth floor, Action. Action for example simultaneously embraces social history, political history, magic and science.

In her preface to *The Art of Memory*,[8] Frances Yates acknowledges the debt she owed to the Warburg where she taught for many years. When she lectured on the Mnemoic works of Bruno Giordano at the Warburg in 1952 she showed her reconstruction of the wheel described in the *De Umbris Idearum* (The Shadow of Things), Bruno's first mnemonic work, published in Paris in 1582. This complex memory system takes the form of a wheel rotating within other wheels, each lined with symbols that represent different knowledges, known and imagined: the arts, languages, signs and so on. The wheels move in opposite directions bringing the symbols into every changing proximity and juxtaposition to one another to imply and suggest imaginative connections to lost understanding.

"This entire globe, this star, not being subject to death, and dissolution and annihilation being impossible anywhere in Nature, from time to time renews

1493 1494 1495 1496 1497 1498 1499 1500 1501 1502 1503

*itself by changing and altering all its parts. There is no absolute up or down,
as Aristotle taught; no absolute position in space; but the position of a body
is relative to that of other bodies. Everywhere there is incessant relative
change in position throughout the universe, and the observer is always at
the centre of things."*

— Giordano Bruno, *De la Causa, principio et uno*
(On Cause, Principle, and Unity)[9]

Frances Yates' studies on the survival of the ancient art of visually
organising, combining and retrieving knowledge may now be
apprehended as early modern solutions to eminently contemporary
problems. The approach to describing and constructing memory,
demonstrated by Bruno's wheel, can be used as a tool to aid the
understanding of the twenty first century's overlay of traditions.

Re-configuring Meaning
As part of the Human Cargo exhibition, the artists' interventions in
Plymouth Museum adopted a number of different approaches to
reflect upon the historical 'apparatus'[10] of slavery that is embodied in its
collections and of our implication in current slavery through everyday
consumerism. The technical term apparatus, used by Foucault to define
the object of his research, can be understood as the network established
between elements, such as discourses, institutions, laws, and so on.
The apparatus has a strategic function and is located at the intersection
of power relations and relations of knowledge. A number of the artists
took a retrospective, historiographic approach to undertaking this task
– a methodology that includes the historical account, the archive, the
document, the act of excavating and unearthing. This 'meta-historical
mode' runs counter to the Museum's historical self-articulations and
legitimations, what Marion von Osten has described as 'exhibition making
as a counter-public strategy.'[11]

1504

1505

1506

1507

1508

1509

1510
First enslaved Africans are
shipped to Hispaniola by order
of King Ferdinand of Spain to
work in the mines.

1511

1512

1513

Framing themselves as 'artists' or 'artist-curator', they made connections between the collections and wider cultural, social and political contexts, which the Museum Curators would have felt obliged to justify within a more empirical and scientific mindset. The artists did not limit themselves to the (potentially reactionary) occupation of history-telling increasingly popular in contemporary art practices; described by Dieter Roelstraete as "closely related to the current crisis of history both as an intellectual discipline and as an academic field of enquiry".[12] Rather, they engaged also with the present. A number of the artists' interventions demonstrated that, after the historiographic turn, a recent critique in contemporary art discourse is emerging – that of a resistance to the fetishization of history. Thus the artists transformed the institution, traditionally a space where viewers are restricted to being passive receptors of meaning, into a 'factory' for the production of meaning to

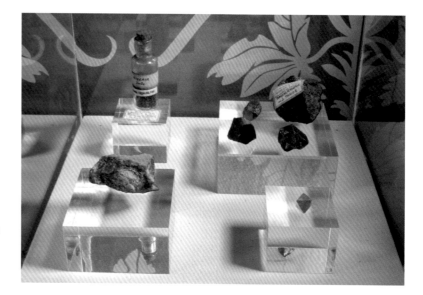

Specimens of diamond, mined in Kimberly Mines, South Africa; gold, Sheba Transvaal, South Africa; and Cassiterite (tin ore), Jos Plateau, Nigeria
Plymouth City Museum and Art Gallery

Lent Lily
Jyll Bradley, 2007
Screen print wallpaper, designed with Claire Turner and George Hadley.
Photographed at Plymouth City Museum and Art Gallery, 2007

which visitors were invited to actively contribute. The artists developed or initiated works, some co-produced with museum visitors or 'off-site' communities, that were contextualised in relation to the Museum's collections but which also functioned in their own right, through reference to contemporary issues and narratives outside of the institution. This re-direction of our attention outwards, beyond the Museum, shed light on the histories and legacies of the Slave Trade within its collections, and their relationship to wider cultural, social and political contexts

The avoidance by a number of the artists to history-telling in the Museum context, can be understood as a tactic to resist being described by, and move beyond, existing discourses of Colonialism and Post-colonialism. Instead, the artists explored the contemporary version of the Transatlantic Slave Trade in the form of economic globalisation and its mechanisms. The most recent iteration of the Guangzhou Triennial of Contemporary Art (China, 2008) proposed to say 'Farewell to Post Colonialism'.[13] It attempted a critical review of the role cultural discourses of Post-colonialism and Multi-culturalism have played in contemporary art. While affirming Post-colonialism's achievements in exposing hidden ideological agenda in society and inspiring new art, the Triennial also purported to examine its limitations for creativity, and called for a fresh start. Its title reflected the current exploded world order of globalisation and a move beyond the old hierarchies of nation and Empire, with their politically correct critique, that described China as 'the other', so releasing China to become the new power within a global order. However, Farewell, rather than goodbye, signals Post-colonialism's imminent return, in another form. Hence the current debate on China's meteoric rise in Africa has been dominated by two extreme and opposite views. One tends to see China's presence in the continent as generally negative, neo-colonial and generating a lot of resentment among Africans. The second view is inclined to see the Chinese presence as largely beneficial, providing African states with generous aid in the form of soft loans,[14] major infrastructure programmes but, above all, providing a balance to traditional European and American dominance of the region. Our own

1525

1526

1527

1528-30
First English ship goes from Plymouth to West Africa and Brazil. The Pole or Paul of Plymouth, captained by William Hawkins, father of John Hawkins, stops in the River Sestos in present-day Liberia.

1529

1530

1531

1532

1533

implication in this shift should also be taken into consideration: China is sourcing raw materials in Africa to produce goods to supply the demands of 'Western' consumerism.

Museum and Mausoleum

In his text 'Valéry Proust Museum', Theodor Adorno discussed the museum in terms of the life and death of artworks.[15] Paul Valéry writes of the museum in terms of death, disorder, and constraint;[16] speaking of the "authoritarian gesture" that takes away his cane and his pipe when he enters the museum. The museum is where "we put the art of the past to death". But Valéry also writes about the "sacred awe" that fills the museum and concludes that this situation has come about through the detachment of artworks from their original settings. He says of artworks "Their mother is dead, their mother, architecture. While she lived, she gave them their place, their definition… While she was alive, they knew what they wanted." Valéry suggests that the architectural 'mother' that gives life to artworks, has been replaced with a different kind of sacred space in the museum, a space of violence and sacrifice which remains as a monumental sepulchre.

Proust, by contrast, speaks of the museum in terms of life rather than death.[17] The museum for Proust is the very mind of the artist, where not the death but the birth of artworks takes place.

Valéry champions the independence of the artwork, its objective character and immanent coherence, over and against the contingency of the subject. Proust by contrast rejects fixed truths and gives primacy to the flux of experience and memory. Adorno suggests that neither Valéry nor Proust is 'right' about art. There must be a dialectic between their positions, where one passes over into the other: Valéry can only become aware of the autonomy of the artwork through Proustian self-reflection in the museum. So, works of art must be sent to their death in order to live. The museum is necessary to achieve this dialectic in art.

Re-imagining the future

In recent years, the prevailing approach of museums and artists in working together has been to respond to what Dieter Roelstraete diagnosed as the 'historiographic turn in art'[18] apparent in a focus on archiving, memoirs and memorials, re-enactment, remembrance, and reminiscence - in short with the past. He associates this retrenchment in contemporary art with a background of depoliticisation and apathy over the past eight years or so, following the invasion of Iraq. Following on from this phase, and with an eye on the possible production of theory of the present and recovery ('excavation') of the future what would an excavation of the future yield, and what would such an excavation site even look like?

It therefore seems prescient to engage with the present to re-conceptualise existing museum display models and offer alternative proposals for how the museum could develop its exhibitions in future. Thus, the approaches taken by the Human Cargo artists' interventions included: working with the co-curators and museum staff on a two-way process of critical reflection throughout the exhibition's development; re-mapping the Museum to challenge the Eurocentric order and classification of objects; designing a 'wallpaper' as a context for the historical objects on display that explored the cultural legacy of the Slave Trade in the collections whilst referencing local industrialized cultivation practices involving migrant workers; transforming the 'white cube' gallery into a 'factory' through a participative project which addressed issues surrounding consumerism and cheap labour; producing a work that reflected on the story of the MSC Napoli cargo ship that ran aground locally recently to make a contemporary analysis of international trade whilst indicating the impossibility of 'telling' the whole story; and adopting the language of everyday consumerism to engage people with ideas about fair trade and reveal the stories behind the production of commodities sold in shops.

The Undesirables
Melanie Jackson, 2007,
Etchings, transcripts,
animated sequences DV PAL,
sound. Photographed in the
Maritime Collection Gallery of
Plymouth City Museum and Art
Gallery, 2007

1546

1547

1548

1549

1550

1551

1552

1553

1554- 1555
John Lok becomes first
Englishman to bring Africans
from West Africa to London to
learn English. They returned
home later to help the English
trade on the Gold Coast.

1555

Perhaps we are now in a position to start thinking, not just about the past, but also about the future again. The artists' interventions, reflected upon in the following pages, offer not only a new look at the past, but point to a possible entirely different museum of the future.

References

[1] Benjamin, W. "Excavation and Memory," in Jennings M. Eiland H. and Smith G. (ed.) Livingstone R. et al (trans.) *Selected Writings*, Volume 2, Part 2, 1931–1934 (Cambridge, MA, The Belknap Press of Harvard University Press, 1999), p. 576.

[2] The exhibition *Human Cargo: The Transatlantic Slave Trade, its Abolition and Contemporary Legacies in Plymouth and Devon* was presented at Plymouth City Museum and Art Gallery 22 September to 24 November 2007 and co-curated by Len Pole and Zoë Shearman.

[3] Agamben, G. *What is an Apparatus?* (Stanford, California, Stanford University Press, 2009 [2006]), pp. 53-4.

[4] A term left over from a time Europe travelled and invented itself with respect to a unified "East".

[5] See De Certeau, M. *The Practice of Everyday Life* (Berkeley, University of California Press), 1984.

[6] See Foucault, M. *The Archaeology of Knowledge* (London, Tavistock Publications, 1972).

[7] Aby Warburg gave his library of 80,000 books to the University of London to form the The Warburg Library in 1944 (to become the Institute).

[8] See Yates, F. *The Art of Memory* (London, Routledge and Kegan Paul, 1966).

[9] *De la Causa, Principio et uno* was printed in 1584 in London by John Charlewood.

[10] Agamben, *What is an Apparatus?* (Stanford, California, Stanford University Press, 2009), pp. 1-24.

[11] Von Osten, M. "A Question of Attitude – Changing Methods, Shifting Discourses, Producing Publics, Organising Exhibitions", in Sheikh, S. (ed.) *In the Place of the Public Sphere?* (Berlin, b_books, 2005).

[12] Roelstraete, D. "The Way of the Shovel: On the Archaeological Imaginary in Art", e-flux Journal (New York, 2009), issue 4.

[13] Guangzhou Museum of Art, Guangzhou, China, 2008, curated by Sarat Maharaj, Johnson Chang and Gao Shiming.

[14] In 2009, China pledged $10 billion in concessional loans to African countries, again bringing to the fore the debate over China's growing profile in the continent.

[15] Adorno, T. W. "Valéry Proust Museum," in *Prisms*, trans. S. and S. Weber (Cambridge, MA, MIT Press, 1983), pp. 175-185.

1556 William Towerson sails into Plymouth from Guinea with African captives

1557

1558

1559

1560

1561

1562 John Hawkins sails out of Plymouth in October with three ships, bound for Guinea and the West Indies. This was the first English voyage to west Africa made with the intention of taking enslaved Africans to the Americas.

Sir John Hawkins

[16] Valéry's remarks on museums are entitled "Le problème des musées" and appear in the volume of essays *Pièces sur l'art* (1934).

[17] Proust's view of the museum is woven into the fabric of *À la recherche du temps perdu*, published in seven volumes between 1913 and 1927.

[18] Roelstraete, D. "After the Historiographic Turn: Current Findings", e-flux Journal (New York, 2009), issue 6

1563
Hawkins returns to Plymouth in September

1564
Hawkins sails again from Plymouth, with four ships. The largest ship was the Jesus of Lubeck, lent by Queen Elizabeth.

THE JESUS OF LUBECK

1565
Hawkins returns to Padstow in October.

Lent Lily *(for Rev. Dr. Rosemarie Mallett)*

Jyll Bradley

Rev. Rosemarie Mallett was giving me a tour of her Brixton church as a prelude to my taking her photograph. It was as if she held a torch to every corner; the torch was her voice. *Here,* she said, looking up, *is what we call the Basilica, where the main church services are held. Just here is the place from which I give my sermons; I do not use the pulpit, I prefer to be closer to the people.* She pointed out a mural by the artist Eric Gill. Recent suggestions that he had been a paedophile had given rise to debate amongst parishioners; how should they view his art? Could a beautiful thing retain beauty, knowing it came from the hands of someone who also practiced ugliness? We paused for a moment. Then Rev. Mallett lead me through a door into the Lady Chapel, a small, dark space – neither square nor round – created by a series of wooden arches. Even though each of these bore large panes of glass the chapel was dark due to its position within the cavernous body of the church. It was the last destination on the tour and, Rosemarie said, one of her favourite spaces; immediately it felt that we had found the right place for her photograph. At the time I was making a series of images of Anglican women priests in their churches. Having myself been brought up in a high church tradition I was exploring a personal root; I was also fascinated as to how these brooding, complex spaces in my adult urban midst were now being energised by so many women; who in my childhood had been excluded.

Rosemarie said that the Lady Chapel was where she came to retreat from the grand gestures of the main church. As our eyes slowly grew accustomed to the light she told me of the journey which had brought her here: from her childhood in the Caribbean, passage to the UK; through the rigours of doctorate study and then to an intellectual life working as a Research Sociologist in the field of psychiatry amongst the Black and ethnic minority communities. She said her calling to the

1565
Hawkins is granted a coat of arms, the crest of which is the torso of an African captive

1566
A third fleet sets sail from Plymouth in ships owned by Hawkins family. Francis Drake serves as an ordinary seaman on one of these ships.

1567
A fourth fleet sails out of Plymouth in October, including the Jesus of Lubeck, with Hawkins in command. Francis Drake is given command of a ship captured off the coast of Guinea

Sir Francis Drake

priesthood had been a slow dawning rather than an epiphany, and came in parallel to a realisation that as she rose through her profession she was becoming ever more distant from her beliefs in social action and community. Then one Sunday in church she was assisting a male vicar at the altar, and looking across at him thought: *I could do that.* At this, Rosemarie switched on the chapel lights at once illuminating the layers of human passage which, in London's Anglican churches with their global congregations, are so very rich. Above the small altar was a Last Supper scene, the disciples animated in shining oranges and blues, their tiny faces picked out in fine detail by bright gold haloes, and, hovering above them a dark skinned, black bearded Christ – so different from the pale, blond figure of my childhood bible. Rosemarie said the painting was testament to a former priest, who, coming from an eastern orthodox tradition, had introduced icons to the church. Then she drew my eye to the altar cloth. It was a deep ecumenical purple; the colour of Lent, and the season in which we now stood; a traditional time of reflection and penitence made all the more powerful that year, because it coincided with the anniversary of the abolition of the transatlantic slave trade, a moment which Rosemarie and her congregation had been active in marking. A trade which, generations on, ran a course through so many local lives, hers included.

 The altar cloth had a distinctive overlay of large, white, concentric circles, ever decreasing in size, like a deep pond into which a pebble had just been cast. Rosemarie told me it was a gift from a congregant who brought it back from a family trip to Nigeria. The Chapel light cast a beam upon the cloth, and as Rosemarie talked, to my mind, it grew brighter. I noticed yet another layer, embedded in the way the weave ran opposite to the ground creating a luxuriant underlying design of flowers; a damask. Commenting on this, Rosemarie said that such styles of African cloth were common, an echo of the slave trade, when rich fabrics brought by European traders found their way to the shores of West Africa as objects of desire – perhaps offered in exchange for human cargo.

 This struck me – of how design, in this case an innocent floral, damask

— Following Page, Left

Lent Lily
Jyll Bradley, 2007
Screen print wallpaper,
Designed with Claire Turner and
George Hadley

— Following Page, Right

*A Conversation: Portrait of
Rev. Dr. Rosemarie Mallett*
Jyll Bradley, 2007
Photograph

1568
The remains of the fleet sails back into English waters, after being routed by the Spanish in the West Indies, and battered by hurricanes. Drake docks in Plymouth, Hawkins returns separately to Mounts Bay. This was the last English slaving voyage for about 100 years.

1569
A Dominican friar, Tomas de Mercado, writes in Mexico against certain forms of the slave trade

1570
First recorded revolt of enslaved Africans in West Indies

1571

1572

1573

1574

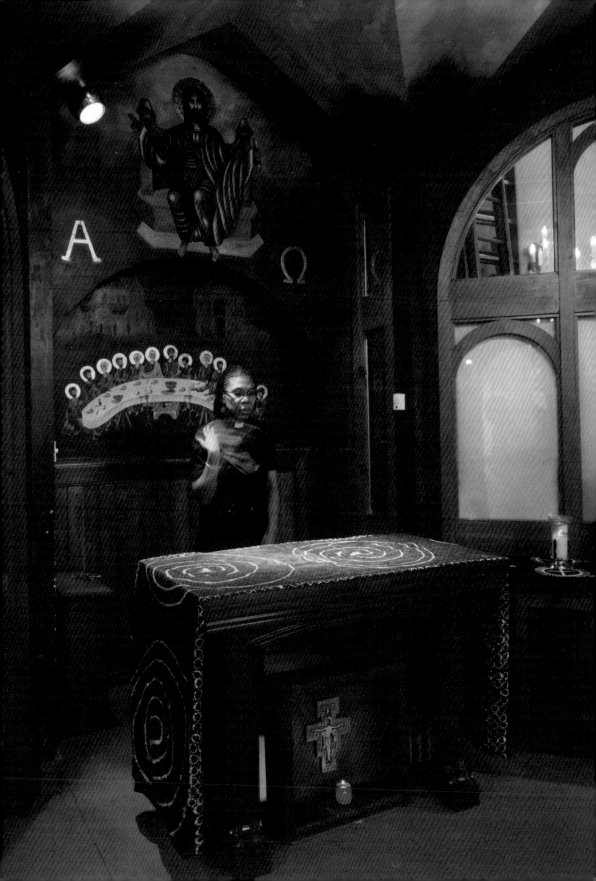

cloth weaves a history through the fabric of our lives in often the quietest, most insidious of ways. It was this moment, in the Lady Chapel with Rosemarie, in a conversation around the creation of images and of things (the how and the why of things coming about, *this thing*, rather than *that thing*) that sparked the making of my wallpaper work *Lent Lily.*

Lent Lily, (which I designed with Claire Turner and George Hadley) was my response to an invitation to create a new piece of work for the Human Cargo exhibition at the Plymouth City Museum. The Museum had many items in its collections which, through one hand or another, had some connection to the slave trade. Of these, few had been shown before, existing in deep storage, as all things are, both tangible and imagined, which cause us feelings of discomfort, or which we cannot reconcile with who we fancy ourselves to be today. Now the museum was dusting down these objects and bringing them to light; reflecting upon an inglorious past and inviting audiences to do the same. It was my intention that the wallpaper would hang in the room where the collections would be shown, contrasting the assumed neutrality of the usually white walls and suggesting the self-reflection many cultural institutions seemed to be going through that year.

If the damask of the altar cloth in Rosemarie's Brixton church inspired the idea of the *Lent Lily* wallpaper, it was the symbol of the daffodil which, in flower arranging parlance, gave me a focal flower for the design. The daffodil: bright herald of Easter redemption and traditional crop of the South West whose arrival to market on the now mythic 'flower train' brought a promise of spring to wintry cities, but whose appearance in the news these days was more likely to concern the hidden plight of the Eastern European migrant workers who harvested them. Stories of pitiless pay for long, cold hours and miserable accommodation; of overturned, uninsured minibuses, broken limbs, lost lives – all for the superficially innocent joy of a handful of flowers.

For the design of *Lent Lily* I took inspiration from traditional English damask patterns, but drew ours into the present through hybridisation. Claire, George and I found our daffodil in a book of botanical paintings

— Opposite Page

Above and below
Histoire des Insectes de l'Europe
After drawings and descriptions by Anna Maria Sibylla Merian (1647-1717)
Published posthumously in Amsterdam by Jean Frederic Bernard in 1730

Plate: CLIX: engraving of 'Narcissus', or Daffodil', or 'Lent Lily'

Plymouth City Museum and Art Gallery: Cottonian Collection ©

1575 Portuguese build a fortress of Sao Paulo at Luanda, in what is now Angola.

1576

1577

1578

1579

1580

1581

1582

1583

1584

(held by the Museum) by Anna Maria Sibylla Merian (1647-1717), a Dutch naturalist who travelled to Suriname and became a lone voice amongst her countrymen in criticising the way planters treated Amerindian and Black slaves. We crossed her daffodil with the floral design from an umbrella from the Museum's collection of slave trade related items. This large green and red tassled piece, the opening of which for the purposes of photographing caused alarm at the Museum, lest it tear, was from Northern Nigeria, donated to the museum at some point by a Lt. Pye. He in turn had gleaned it from the Keffi-Abuja Expedition in 1902, a venture long lost in translation whose purpose it seems was to pacify a local uprising against the newly colonising British. The label tied to the handle of this umbrella, as though it were a piece of lost luggage reclaimed only now by the present, stated that it was then worthy of exchange for (approximately) six slaves.

Once the odd marriage between these disparate flowers was complete and our design ready, the *Lent Lily* paper was screen-printed at Cole and Son, one of the oldest wallpaper companies in the world whose archive included the designs of William Morris and Augustus Pugin, and whose papers, we were told, graced the walls of so many palaces of power and empire – those of Buckingham and of Westminster. On the day of the printing, a chilly, grey September morning we arrived very early at Cole and Son's factory situated in the most unlikely of places, a light industrial estate in Stamford Hill, North London. There, clutching cups of hot coffee, we watched the printers as they squeezed our chosen bright yellow ink through fine gauze onto the shimmery gold ground. A few days later, once the wallpaper had dried, it was dispatched to Plymouth and my field of strange golden daffodils, for this is what it now resembled, was placed in the hands of a local decorating expert who, whilst praising the texture of this bespoke creation, lamented the uneven-ness of the walls upon which it was to be hung.

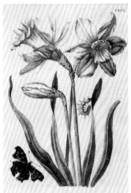

The gallery was duly furnished with shiny glass cabinets and in turn these were filled with the collections: an ivory armlet from Benin, a harp lute from Cartagena, figures, masks, a hammock, chains taken from two

captives freed by Rev. Townsend a Christian missionary in Abeokuta, a game board, a fly whisk, weights for gold, cowrie shells. When all was said and done, it seemed to me these objects now beheld each other, like deep sea divers surfacing for air, and the room bristled with the beauty of the things and the ugliness through which they came to be there.

~

It is three years since I made *Lent Lily* and writing gives pause for self-reflection. I remember that from the start of the work toward the show any notions of worthiness were off-limits: the litany of human suffering continues and whilst we may be ever rich with information – that hors d'oeuvre of the modern age – we seem none the wiser for it. I remember that I didn't want to make an object for the exhibition, nothing, at least, that took up space. Then, the world seemed overwhelmed with objects, all those museums bringing out their spoils. I wanted instead to make something marginal, seductive even, that quietly hung about the walls. Something which might at first register simply as a colour or a light or a glow. Or, a: *what do you think about that for a wall-paper for the sitting room? No, second thoughts, maybe it's a little garish...* I hoped that such feelings might provoke, say, a reason for lingering longer in this windowless yet inexplicably warm, yellow room, slightly delaying the inevitable departure home into the increasingly dark, wet, autumnal streets. And I hoped that accordingly we might look a little longer and that something might catch our eye, maybe a small wooden sculpture, the way, perhaps that a reflection of a yellow daffodil haloed that sculpture, perhaps also capturing the viewer's face in the hour glass of the cabinet. Ultimately, I hoped to have created a space where a conversation might ensue, one that fell between words, images and objects, that criss-crossed time and geography, iniquity and pleasure; a conversation such as I had enjoyed that day in the Lady Chapel in Brixton with Rev. Rosemarie Mallett. Later, Rev. Mallett wrote me a letter in response to *Lent Lily.* In it, she said:

1596

1597

1598

1599
Dutch involvement with African trade begins. The Dutch have access to better selection of European trade goods via Amsterdam – especially cloth and iron.

1600

1601

1602

1603

1604

"...the use of wallpaper is to me symbolic of the way we normalise so many things that are actually immoral or unethical, but because they do not affect us directly or we cannot see the links with what we get and how it comes to us, we background it in the way wallpaper is back-grounded in our everyday existence."

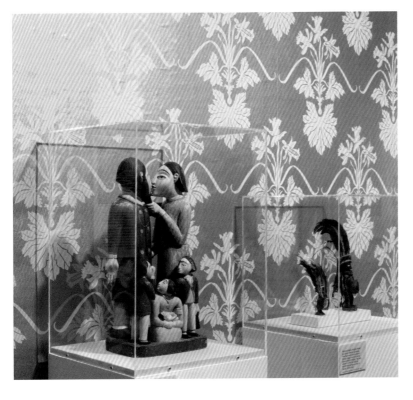

Lent Lily
Jyll Bradley, 2007
Screen print wallpaper,
Left: Figure group, painted wood, made by a BaKongo carver in the Democratic Republic of the Congo, early 20th century. Plymouth City Museum and Art Gallery
Right: Male power figures, used by priests in BaKongo villages, made before 1885, collected in Cabinda, Central Africa. Royal Albert Memorial Museum & Art Gallery, Exeter
Photographed at Plymouth City Museum and Art Gallery, 2007

1605

1606

1607
The first English colony in the Americas founded at Jamestown, in Virginia.

1608

1609
Plantations established by English on Bermuda

1610
English settlement in Massachusetts

1611

1612

1613

China and the Unbearable Lightness of Sweatshops

WESSIELING

On a sunny afternoon, a retired seamstress, an English lady in her seventies, told us how she and many around her were once child labour. She recalled the many garments that she sewed with her tired hands, and asserted that it would have been impossible for Britain's economy to have recovered so quickly after WWII without the pool of cheap, available labour. 'This is just what it is. Today, it is China; tomorrow will be Africa.' Businesses never stop hunting for the lowest possible manufacturing cost.

On the day of our mobile art-unit *Sweatshop* showcase at Plymouth's Respect Festival 2007, BBC News reported Gap's exploitation of child labour in an Indian factory. The company was condemned for its actions, and the garments were then ordered to be removed from Gap's stores. This news complemented the anti-sweatshop message of our project. During the festival, many visitors passed by to praise our work, acknowledging our initiative.

The public support for our anti-sweatshop cause was heartening, despite the fact that our efforts are likely to contribute little towards changing the situation. The issues surrounding sweatshops are another example of history repeating itself. Sadly, excessive media coverage and increased public awareness of the subject is not helping to resolve the problem. There are two sides to the debate on sweatshops: sweatshops are the inevitable result of globalisation and free market V sweatshops are exploitation of labour and violation of human rights.

Sweatshops as entertainment
Lately, sweatshops have taken on new roles: entertainment and therapy. Some documentaries and television programmes on them offer insight into the laughter and tears of the youngsters who work there. One

1614

1615

1616

1617

1618 King James I establishes the Company of Adventurers to Ginny and Binny (Guinea and Benin). Robert Rich, later the Earl of Warwick, controls the Company. He owned a tobacco plantation in Virginia.

1619 First record of Africans being landed in Virginia

1620

1621

1622

documentary reveals the bittersweet lives of Chinese adolescents working in a sweatshop. Another features young British people sent to deprived factories in a developing country for the experience. The entire documentary focused upon the volunteers' hardship in the sweatshop rather than recording the real voices of the local workers. It focused upon how these twenty-something people felt working in Indian sweatshops, as if they are exclusive to the developing world. The misconception that sweatshops are only found in developing countries like China and India shifts our attention away from the real problem. For example, in the United States, 90% of local factories are sweatshops. Those living in the developed world seem unaware of local sweatshops to which equal concern is required. Casting the blame upon the governments of developing countries is an all too easy reaction.

Such kinds of television programme are far from the reality of working in a sweatshop. They do not outline the fundamental problems, nor engage in discussion regarding the complexity. Even when local workers are the central characters in other documentaries and programmes, the perspective is still that of the developed world. There is no consideration of the fact that in some developing countries, many adolescents lead a better life by working in a factory. To many, working in a factory is an escape from a troubled life in a deprived village. The financial rewards and personal development are huge compared to struggling in a poor village. The skills acquired in a factory by many young workers can benefit them for life. However, this is not to encourage the continuation of child labour, but to emphasise that many reports and documentaries fail to comprehend or convey the complexity of the subject.

Low-cost therapy

While documentaries and programmes on sweatshops may inspire some to reflect upon their pattern of consumption, they are broadcast alongside programmes about unethical fashion. Style programmes encourage consumption, but the main factor that promotes consumption is high street fashion, which, is often manufactured unethically. Fashion

1623

1624

1625
July: Cornish fishing villages
attacked by Moorish sailors
from North Africa - 200 taken
as slaves

English establish first
settlement on Barbados

1626

1627

1628

1629

1630

1631
Baltimore, in County Cork, is
overrun by Islamic soldiers;
237 men, women and children
taken to Algiers

programmes suggest that affordable fashion can improve your self-confidence, spice up your sex life, and make you appear younger, all from purchasing cheap garments with a 'Made in China' label.

As the world's largest clothing manufacturing country, China now dresses British people. However, their makeover comes at the expense of the enslavement of factory workers, many of them impoverished and paid in pennies. High street fashion provides the developed world with affordable psychotherapy in a variety of colours, sizes and brands. Yet most high street labels are heavily involved in the sweatshops. To my knowledge, no programme has yet considered an ethical approach to the nation's fashion. Nor do the wearers of fashion ask to be styled ethically. Even though the demand for organic and free-range food is increasing, the growth of ethical clothing proceeds at a snail's pace. Supermarket clothing is now competing with low-cost fashion, and disposable sweatshop clothes are filling the nation's wardrobes. Are we wearing the sweatshops on our backs?

Sweatshop

Our Human Cargo project *Sweatshop* was a process-led work consisting of a mobile unit and a series of workshops. During the exhibition, workshop participants were invited to make protest flags featuring their views on the issues surrounding sweatshops. Local institutions and communities joined our workshops, and our mobile unit travelled beyond the Museum to reach more people. Rescuing trucks of used clothes from charity shops, participants made their flags from discarded children's clothes that looked as good as new. While making their flags in the Museum, we invited participants to express their feelings on the subject by drawing on the gallery wall which was eventually filled with spontaneous drawings. On the last day of the exhibition we hung the flags on the outside of the Museum building and in the lobby. The closing event saw abundant flags with witty slogans ranging from '[S]ave [O]ur [S]laves' to 'High Street Sweatshop', to 'Think B4 U £' to 'Mind the Gap'. Inside, the gallery revealed the participants' drawings. Some reminded us

1632 1633 1634 1635 1636 1637 1638 1639 1640 1641 1642

'a £ of clothes, a £ of flesh'; others proposed a retail-free day.

The participants' enthusiasm warmed our hearts and emphasised the importance of addressing such a complex subject. We understand that the sweatshop problem will not be resolved overnight. The aim of *Sweatshop* was to open up discussion about and consider possible action against the subject. As multinational corporations and governments join forces to ensure a global free market, the burden of sweatshops now rests with consumers. Clothing consumption and its association with sweatshops now requires a second thought, reflected in the participants' enthusiasm for our project. Discussion of over-consumption and its relation to sweatshop was heard while sewing their flags. When participants hesitated in cutting up used clothes for flag-making because they looked so new, we knew that we had stimulated their thoughts on sweatshops and fashion consumption. *Sweatshop* conveyed its message to many who care about the well-being of humans around the world.

— Following Pages

Sweatshop
Lisa Cheung + WESSIELING
Process project, mobile workstation sculpture, public event facilitated by the artists and the Museum Community Outreach Team. 2007 Photographed at Plymouth City Museum and Art Gallery

1643 1644 1645 1646 1647 1648 1649 1650

1651
First Navigation Act brought into force by Cromwell. This means that foreign ships are banned from importing or exporting goods to or from English colonies.

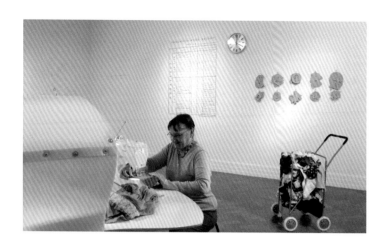

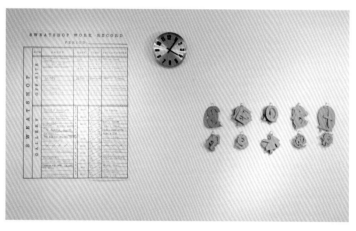

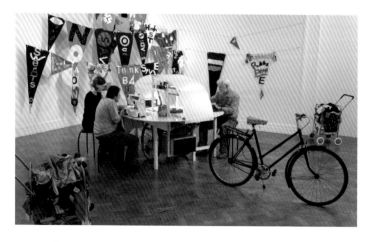

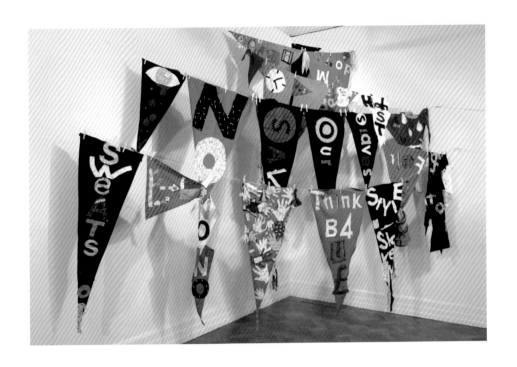

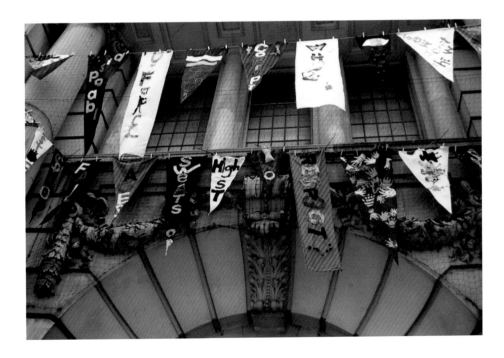

Raimi Gbadamosi

"...from and after the First Day of May One thousand eight hundred and seven, the African Slave Trade, and all manner of dealing and trading in the Purchase, Sale, Barter, or Transfer of Slaves, or of Persons intended to be sold, transferred, used, or dealt with as Slaves, practiced or carried on, in, at, to or from any Part of the Coast or Countries of Africa, shall be, and the same is hereby utterly abolished, prohibited, and declared to be unlawful..."

— Extract from the 1807 Act of Abolition of the Transatlantic Slave Trade

1807 Act of Abolition
Parliamentary Archives

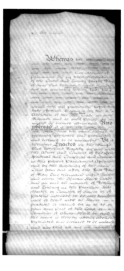

As artist-adviser to the Human Cargo exhibition, Raimi Gbadamosi worked with the curators on a two-way process of critical reflection throughout the development of the project. He selected objects from the Museum's reserve collections for inclusion, and produced a new video work, *Theactre*, and a Museum trail, *Drake Circus*. *Theactre*, a two screen audio-visual exposition of the 1807 Parliamentary Act of Abolition of the Slave Trade, was presented as a two-screen work. The film records a reading of the Act, an attempt to animate it, contextualise the exhibition, and pull the mind back and forth between 1807 and 2007. The Act has a unique place within British History, there are few Acts that have been for the direct betterment of people other than the already empowered. The Representation of the People Act (1928) and The National Insurance Act (1946) are two documents of similar spirit. The Act underwent various changes during its passage through both Houses of Parliament, as demonstrated by the various amendments stitched onto the parchment roll in the Parliamentary Archives. *Drake Circus* explored the cultural legacy of the Transatlantic Slave Trade in the collections of the Museum. It 're-mapped' the institution, a bit like remixed music, in which the artist took the role of Master of Ceremonies, performing the spectacle of history. By bringing in different cultural perspectives, Gbadamosi challenged the Eurocentric order and classification of objects within the

1652

1653

1654

1655 British seize Jamaica from Spain. 1500 enslaved Africans flee into the mountains. The Maroons, as the free Africans became known, form independent communities in the mountainous parts of the island.

1656

1657

1658

1659

1660 Foreign ships banned from importing or exporting goods to or from English colonies

Theactre
Raimi Gbadamosi,
2007 (film still)
Filmed by, and edited
with, Alia Syed

institution and encouraged visitors to look at the collections anew. In
re-naming its public spaces and galleries, the Shop became the 'Booty
Store'; the Explore Nature Gallery, 'Keeping It Real'; and China Connection
Gallery, 'Fragile', etc. Gbadamosi introduced the language of black street
culture and everyday consumerism into the Museum context. Gbadamosi
re-designed the floorplan of the Museum, showing both floors as one
continuous level, in contrast to the convention of Western mapping,
which abstracts space. This privileged the physical journey of visitors
through the galleries, in so doing, the artist shifted the power from the
institution to the individual. For the map, as with much of his work,
Gbadamosi used the colours black, yellow, and white, alluding to racial
designations. He gave each leaflet a different edition number, defining it
as an artwork, which visitors were invited to take away with them. The
objects selected by Gbdamosi for inclusion in the Museum trail included
Star Wars figures, which function as popular representations of the
'Alien', unquestioned colonialism and natural superiority; records by Jimi
Hendrix and Bob Marley, the ultimate icons of black alternative culture;

The Company of Royal
Adventurers into Africa
established by James, brother
of Charles II; Charles invested
heavily in the Company.

King Charles II

1661

1662

1663
The principal focus of the
Company of Royal Adventurers
is on gold. Gold coins, called
Guineas are first minted.

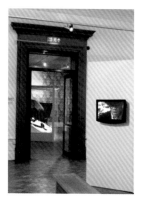

Theactre
Raimi Gbadamosi, 2007
Two-screen film work.
Photographed at Plymouth City
Museum and Art Gallery, 2007.

— *Opposite Page*

Drake Circus (detail)
Raimi Gbadamosi, 2007
Plymouth City Museum and Art
Gallery trail, hand numbered
edition of 2000 leaflets.

— *Following pages*

Drake Circus
Raimi Gbadamosi, 2007
Items selected for inclusion
in the Museum trail from the
displayed collections.
Photographed at Plymouth City
Museum and Art Gallery, 2007

a display of skeletons illustrating the Darwinian notion of hierarchies in development; domestic silver used for goods traded through the Slave Trade; paintings of Napoleon (who re-established French colonial slavery), of the Collector William Cotton, and Slave Trader Tarleton. Gbadamosi also selected items from the reserve collections of the Museum for inclusion in the exhibition. These including a ½ carat diamond from Kemberley (now Kimberley), South West Africa; pickled Shark and Dogfish specimens from the Atlantic, species of which might have fed on the bodies of enslaved Africans pushed overboard from Slave ships; clay pipes in varying sizes, showing how the value of tobacco decreased as it was traded; an Eighteenth century porcelain figurine representing 'Africa'; sugar bowls; coffee and chocolate pots. Domestic items were arranged as a place setting to show how slavery was an everyday part of people's lives then, as now. (ZS)

. . .

Raimi Gbadamosi: The Transatlantic Slave Trade has become the final word in what it means to be an African outside Africa, so history is constructed as pre-slavery and post-slavery. Objects and artefacts then become representatives of what it means to be human, so one of the discussions we had in putting the Human Cargo exhibition together was what the role and function of objects were in their own right? How does one put something in a gallery under the umbrella of the question of the abolition of the Slave Trade without it becoming a marker of either the subjugation of humanity, or simply of something frivolous, or being inventive, significant, disposable, demoralising, weakening, demanding, damaging? All of the things that people produce construct part of their existence. So, an object made in Ghana, need not necessarily be something hugely significant in of itself: it has significance because it is part of a larger discourse – if it is put under the umbrella of an exhibition of this nature it suddenly takes on new meaning. All of these questions

1664
The British take over control of Cape Coast Castle. This Castle remained the headquarters of the British presence in West Africa until 1877.

1666

1667

1668

1669

1670

1671

1672
The Royal African Company (RAC) replaced the Company of Royal Adventurers. It maintains the trading posts along the coast of West Africa, and has a monopoly of the west Africa trade.

DRAKE CIRCUS

A PARTICULAR
MAP OF
PLYMOUTH CITY
MUSEUM AND
ART GALLERY

©RGb 2007
©PCMAG 2007

DRAKE CIRCUS

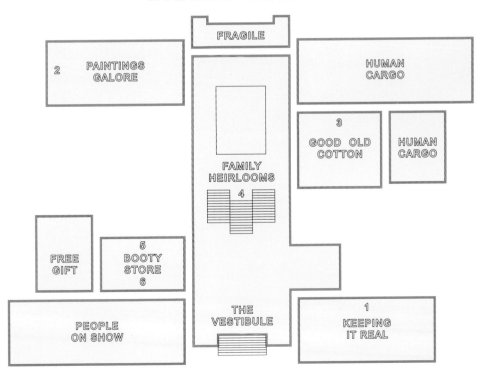

FRAGILE

2 PAINTINGS GALORE

HUMAN CARGO

3 GOOD OLD COTTON

HUMAN CARGO

FAMILY HEIRLOOMS

4

FREE GIFT

5 BOOTY STORE 6

PEOPLE ON SHOW

THE VESTIBULE

1 KEEPING IT REAL

1

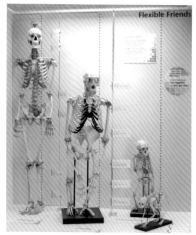

2

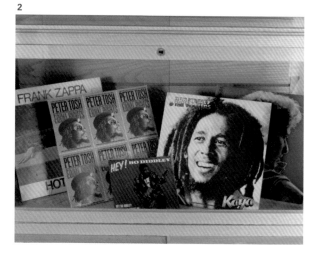

3

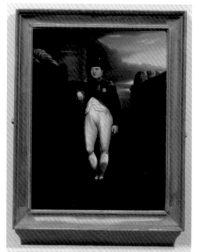

4

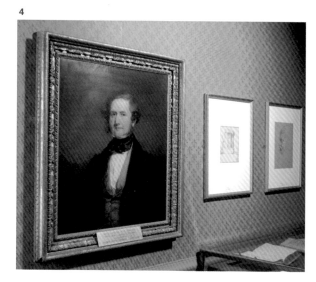

1
Skeletons, left to right:
Human, presented by
J. Greenway Esq, formerly the
property of Dr. H. Greenway,
1899. Gorilla, purchased from
E Gerrard & Sons, London 1903
Chimpanzee, gift of E.H
Bostock, Bostock & Wombwells
Travelling Menagerie, 1916
Monk saki (New World
Monkey), purchased from E
Gerrard & Sons, London, 1904
Photograph: Explore Nature
Gallery, 2007

2
Records, left to right:
Frank Zappa *Hot Rats* (1969),
Peter Tosh *Equal Rights* (1977),
Bo Diddley *Hey!* Bo Diddley
(1962), **Bob Marley & the
Wailers** *Kaya* (1978), *More Bob
Dylan Greatest Hits* (1972)
Photograph: *People's Plymouth*
Collection, sited in the Museum
shop, 2007

3
*Portrait of Napoleon on the
Bellerophon*
J. Harris
19th century
Oil on canvas
This is a version of the painting
by Charles Locke Eastlake
now in the National Maritime
Museum.
Photograph: Maritime
Collection Gallery, 2007

4
*Portrait of William Cotton MA
FSA (1794-1863)*
Stephen Poyntz Denning
(1795-1864)
Oil on canvas, 1845.
Photograph: © Cottonian
Collection Gallery, 2007

5

6

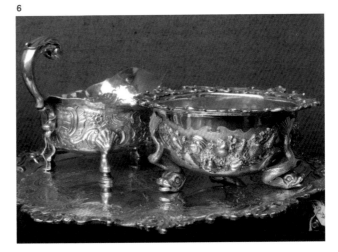

7

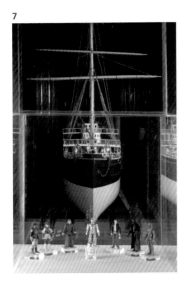

8

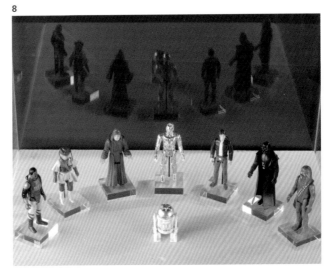

5
*Portrait of Col Banastre Tarleton
(1754-1833)* engraved by
John Raphael Smith
(1751/2-1812) after
Sir Joshua Reynolds PRA
(1723-1792) mezzotint
engraving; published:
London, 1782.
Photograph: © Cottonian
Collection Gallery, 2007

6
Salver, Silver, by **John Holland**,
London, 1745.
Sugar Bowl, Silver, by **George
Hindmarsh**, London, 1738.
Cream Jug, Silver, by **Thomas
Parr**, London, 1745.
Photograph: Applied Art
Collection Gallery, 2007

7
Star Wars figures, 1970s, with
SS Austral, 1882, ship model,
scale 1:48.
Photograph: *People's Plymouth*
Collection, sited in the Museum
shop, 2007

8
Star Wars figures, 1970s,
left to right:
Lando Calrissian, Princess Leia,
Sith Lord, C-3P0, Han Solo,
Darth Vader, Chewbacca,
centre: R2-D2
Photograph: *People's Plymouth*
Collection, sited in the Museum
shop, 2007

are troubling and difficult. On a number of occasions I have been asked how I feel about being engaged in an exploration of the year 2007. It strikes me that it must be equally difficult for anyone to engage with issues of slavery and the trade in humans, and the dehumanisation, both of the person who was being enslaved and the person carrying out the slavery. One is not separate from the other. The fact that I am of African origin does not in any way mean that this destruction of common humanity should have any more weight on me.

I want to speak about my visceral response to seeing the dogfish which I selected from the Museum's reserve collections for inclusion in the exhibition. It is a fish which resides in the Atlantic, and as we all know people were thrown overboard on their way from Africa to Europe, and maybe one of the forbears of the fish – or this one, for I don't know how long it's been in formaldehyde – would have eaten enslaved people thrown overboard as they were transported across the Atlantic, because they were literally food for fish. Prince put it very well in *Call My Name*, where he talks about beauty causing pause: he sees a women and realises how beautiful she is and then he stops. The fish did the same for me. There was something about the fish that forced me to stop: it says so much about things we can no longer see, but that we know exist.

I am interested in how things exist within a market. An art gallery is a precursor to a market and, although it functions differently, the Museum is also an entry point. *Drake Circus* is a Museum trail and an object, a numbered multiple, a commodity about the commodity of the museum. It's also a way of entering into the museum and making visitors look anew in ways that both empower and disempower objects. It's like those science fiction films where aliens arrive with death rays to attack a place. For those of you who have seen *Independence Day*, you'll know what I'm talking about. The moment of destruction becomes a focal point and everything else around it becomes much more obvious: you suddenly notice what is happening.

Kodzo Gavua said at the beginning of this discussion that one of the things that has lasted, despite the Slave Trade, is creativity: and I agree.

1673

1674

1675
Rebellion in Barbados. It is suppressed: 11 beheaded, 6 burned alive, 25 executed, 70 flogged or deported.

1676

1677

1678

1679

1680

1681

1682

Creativity is one of those rather awkward words. In the International Slavery Museum in Liverpool the legacies of the Slave Trade are listed, frustratingly, as carnival and music. The legacies can't be summed up in this way. This is why I want to question: what is the role of the artefact within this kind of discussion? What is the role of a sugar bowl, which we take for granted? What is the role of a dish? What is the role of a big house? What is the role of the Victoria and Albert Museum in London? And what is the role of these objects and how do we face them within a year like this, and an exhibition like this? The role of the object and how one negotiates it within the space of a museum, has been my driving concern in relation to this exhibition. I was concerned that the burden of representation of the Slave Trade, or of slavery, no longer rested on one particular person. There needed to be a shift and new understanding of how we choose to view and engage with the Slave Trade.

Zoë Shearman: I'm interested in the differences between your decision-making in choosing objects from the reserve collections for inclusion in the exhibition, the way you approached it as an artist-curator with a subjective mindset, and the way that museum curators are informed in their decision-making, which seems to be concerned with ascertaining the 'truth'.

RG: This is about what constitutes the role of an object in my imagination, and yes, they were subjective decisions. I am not laying claim that I know for a fact that these things occurred, but that it was possible. Gut instinct based on an understanding of the material before it is scrutinised allows for a different way of engaging. I encountered objects from the collections and allowed alternative histories to be constructed, outside of the histories one would normally expect. These objects told me much about marginality. Things that happen at the margins of history allow us to see what probably happened for a greater number of people than for those of whom history is written.

1683

1684

1685

1686

1687

1688

1689

1690

1691

1692
Potential rebellion in Barbados discovered. Ringleaders are executed.

Tony Eccles: Has Abolition 200, this year's commemoration of the bicentenary of the abolition of the Transatlantic Slave Trade, 'dealt with' issues, or is this a starting point: Where do we go from here?

RG: 2033 will be the next big date for another national 'pat on the back'. What isn't mentioned are the twenty or so other acts that deal with the trade in slaves and the innumerable laws to do with property ownership under colonial rule. Part of the awkwardness with this commemoration is to do with the fact that most of the marking of Abolition 200 has happened within museums. Museums and the Houses of Parliament are the ones celebrating one of the few acts of parliament that has a profound positive impact on this nation and the world. The Heritage Lottery Fund and other institutions allocated funding for Abolition 200. These are all little catchment areas of desire, and desire is both pain and pleasure and all those things come together in this year.

Kodzo Gavua: To sustain this work, museums need to work with schools, particularly in countries where there are ethnic majorities, like Africa, who have been affected by the Trade. How do we disseminate this information to those that don't have the opportunity to visit the museum exhibitions? It's time the museums take it away from the domain of the politicians. This began as a political exercise, politicians wanted to celebrate this year, and so it has trickled down to all parts of society, but the museums have the responsibility of carrying this forward, just as artists and any other group of people who have been touched by the marking this year.

Len Pole: In a way the politicians have usurped the work that's been done over the last fifteen or twenty years in the heritage industry. Many archivists, historians and cultural activists have been working behind the scenes for decades to enable this bicentenary to become a marker. It's been a long and painful journey for many committed people. The heritage industry is not one that has the means of the mass media. The

1693

1694

1695

1696

1697

1698
The monopoly of the Royal African Company's trade in West Africa is lifted. Others wishing to trade to West Africa had to pay 10% of the value of their cargo to the Company.

1699

1700
The ship Daniel & Henry sails from Dartmouth on a slaving voyage to Guinea and West Indies.

movement has been growing, very slowly, but the challenge now is for it to snowball, to gather pace and momentum.

RG: What I'm trying to envisage is a contemplative, investigational exploration of the Slave Trade and its legacies in the contemporary context, involving people from the so-called African diaspora. It's not the end of the point, it's the start of the point.

> — *Human Cargo* seminar, University of Plymouth,
> 17 November 2007, transcribed by Gill Gairdner.

The Daniel & Henry

1701
The Daniel & Henry returns to Dartmouth, with five tons of muscovado sugar and debts of over £1500. About 220 West Africans had been sold into slavery; a great number died during the voyage.

View of Plymouth Sound, about 1675

Melanie Jackson's *The Undesirables:*
Visualizing Labour in the era of Globalisation

Liam Connell

— Opposite Page

A Panorama of Branscombe Representing The Wrecking Of Panamax Container Vessel MSC Napoli And Of The Extraordinary Cargo And Splendid Excitement Of The News Media
Melanie Jackson, 2007
Etching

Two versions of Melanie Jackson's *The Undesirables* were commissioned, in association, for the Port City and Human Cargo exhibitions which ran concurrently in Bristol and Plymouth, in 2007. These exhibitions concerned migration and exchange, in different ways and Jackson's work speaks directly to both issues. At first sight the work seems principally concerned with the global movement of goods rather than the global movement of people but, the more we consider how it interrogates the movement of goods, the more we realize that it shows how labour moves across the globe in the form of tradable commodities. *The Undesirables* is a composite work comprising several elements which need to be read in combination with each other. Most prominent of these is a series of paper models and etched drawings which depict the grounding of the MSC Napoli on Branscombe beach in Devon, UK, at the start of 2007. The Napoli's grounding prompted controversy because of its earlier running aground in Singapore, its proximity to the English shoreline, the speed it was traveling in hazardous waters and because its cargo-weight was misreported in an attempt to evade regulation on total weight and excise duty.[1] Such details speak of the systematic evasion of the regulatory structures for free trade and suggest comparisons with the attempts of undocumented labour to cross national borders. However, in the public awareness of the Napoli, these issues were substantially overshadowed by manufactured outrage at the scavenging of its beached cargo by the local population. Many of those who retrieved items from Branscombe beach believed that they were working within the existing laws of salvage and well-established custom regarding flotsam. Yet the popular press quickly defined their actions as looting, a view endorsed by

CARGO WASHED UP ON SHORE

- UP TO 50 MOTORCYLES MARKED "BMW"
- STEERING WHEELS
- A 4×4 VEHICLE (MARK UNKNOWN)
- A TRACTOR
- EXHAUST PIPES
- SUN VISORS
- NAPPIES
- DOLLS
- WOODEN WINE BARRELS
- 36000 BIBLES WRITTEN IN XHOSA
- 10 TONNES OF KING EDWARD POTATOES
- HYPODERMIC SYRINGES
- MILK
- CASES OF FROZEN FISH
- FLIP FLOPS
- SUNGLASSES
- OIL PAINTINGS
- DOG FOOD
- CAMERA FILM MARKED "FUJI"
- LARGE BALLS OF WOOL
- MORPHINE

- BOTTLES OF WHISKY
- USED OFFICE SUPPLIES
- GAMES MARKED "NINTENDO × BOX"
- BEAUTY CREAM MARKED "L'OREAL REVITALIFT"
- CHOCOLATE BISCUITS MARKED "TROY" & "DANCE"
- SHAMPOO MARKED "PANTENE PRO V"
- BATTERY ACID
- DOLLS HOUSES
- CARPETS
- PERFUMES MARKED "LANCOME"
- BRAKE FLUID
- BABY FOOD
- TRAINING SHOES MARKED "REEBOK"
- TRAINING SHOES MARKED "NIKE"
- DECORATIONS FOR CHRISTMAS
- A CHINA TEA SET
- FAMILY PHOTOGRAPHS
- FOOTBALLS
- LEATHER JACKETS

CARGO BELIEVED TO BE ONBOARD OR LOST AT SEA

- NEW 4 SEATER CAR MARKED "MORGAN V6"
- ORGANOPHOSPHATES PESTICIDES
- 130 CONTAINERS OF CAR PARTS MARKED "VOLKSWAGEN"
- 42 TONNES OF METHYL BROMIDE
- CARBENDAZIM
- PHOSPHORUS
- ORGANOPHOSPHATES WEEDKILLER
- 160 TONNES OF NICKEL
- RUMOURS OF BANKNOTES, ARMS AND EXPLOSIVES

the police and members of the political class. Many column inches were devoted to protecting private property-rights and rather less to defending maritime law and the coastal environment. In effect this expressed the neo-liberal discourse of free trade in miniature where individual property rights supersede any collective rights. Jackson's depiction of the Napoli focuses upon the contradictions between these competing rights.

Jackson describes her work as a 'diorama', taking her cue from the nineteenth-century miniature scenic-depictions and also drawing on earlier eighteenth and nineteenth-century model enactments of sea battles.[2] The centerpiece of the diorama is a large model of the Napoli, listing at its bow, with a number of cargo containers spilling onto the gallery floor in place of the sea. Though it is surrounded by depictions of the spectacle on Branscombe beach, it is the ship which visually dominates not least because it is separated from the other items by a stretch of empty floor. The depiction of the listing container-ship recalls some of the most familiar images of the Abolitionist movement and Jackson's choice of the Napoli was partly influenced by its destination in Africa which serves to update earlier narratives of the Atlantic trade.

While Jackson's work makes no literal allusions to the history of slavery, nor to its contemporary forms, her representation of the rigid lines of modern container transport underlines continuities in how we imagine the rationalized geometries used for the transportation of capital. In particular, Jackson's model shows the formal lines of the cargo container from above, in contrast to the manner in which they would usually be seen from alongside. Although the presentation of the Napoli in overview allows Jackson's model to suggest the tightly packed bodies of the famous *Description of a Slave Ship*, published by the London Committee of the Society for Effecting the Abolition of the Slave Trade in 1789, it avoids the need to literally repeat this design. As Marcus Wood has argued, the *Description* utilizes the 'precise style of naval architecture' and 'a precise set of measurements' to produce a 'dehumanising commodification of the slave through' its 'uncompromising objectivity'.[3] In this way, the *Description* reveals important truths about the

1713 1714 1715 1716 1717 1718 1719 1720 1721 1722 1723

transatlantic slave-trade, where the transport of slaves was a crucial component in making the passage from Europe to the Americas profitable. Where the *Description* transforms the labouring body into the form of the commodity, *The Undesirables* echoes this transformation by showing how modern international trade similarly transforms the objects of labour into consumerist commodities. The depictions of beached consumables in Jackson's record of the Napoli accident shows the object of consumption uselessly spilling into plain sight from the recesses of global logistical infrastructures. The discontinuity between object and location renders these consumables ephemera but the story that they tell is one of desire unhindered by the absence of any apparent use value.

Questions of labour are addressed obliquely in this section of the work but they emerge more directly in an animated digital video which is mounted on a wall alongside the diorama and forms a continuous sound track to all of the visual components. This animation depicts the workings of a container port alongside interviews with dockworkers in Bristol, Plymouth and Southampton. One of Jackson's aims for this element of the work is to illustrate how the processes of modern global transportation have been rendered invisible. The film seeks to make visible this invisibility and it achieves this in two main ways: first, through interviews with dockworkers, which recount a series of stories involving different kinds of unseen manifestations of global transportation; second, in the visual field, the bureaucratic regulations governing the port area, manifests a visual absence which is the only effective way to represent the invisibility of labour's movement through Britain's international docks.

Three elements of the dockworkers' stories seem particularly noteworthy. The first of these is the historical transformations of dock-work over the working-life of a particular stevedore (since the 1960s to the present day). In his account he recalls the considerable labour required to unload a ship of open cargo in the late 1960s compared to the pared-down work required to remove containerised cargo in the modern dock. This offers a personalised version of theoretical insights by the likes of David Harvey about the role that the compression of global

1724 1725 1726 1727 1728 **1729** London Quakers Annual meeting: advice against owning slaves is given. 1730 1731 1732 1733

geographies plays in occluding labour.[4] Yet the account in Jackson's video also points to the loss of labour in another, more abstract form. One consequence of the containerisation of cargo is that labour-migration, both as commodities and as illegalised migrants, is visually obscured. In contemporary international transport, it is impossible to confirm, or even to know, the nature of the goods transported or, increasingly, their country of origin or destination. Modern transportation veils cargo within anonymously identical containers which, as a result of the relaxation of trading barriers, pass across borders largely unscrutinized. The occlusion of origin hides the circumstances of production and in effect conceals labour once it has entered into the circuits of exchange. This obviously links to the main diorama because the under-reporting of cargo weight raises uncertainties about cargo manifests which, protected by the visual blankness of containerisation, remain hidden from proper scrutiny.

The two other elements of the stories in the animation that I wish to pick out also address the potential for concealment offered by containerised transport. However, unlike the first element, these stories highlight the possibilities of resistance to the occlusion of labour by recounting moments where embodied labour occupies the spaces of objectified labour in defiance of its intended function. The first of these stories recounts an incident where the dockworkers find a broken container which is full of alcoholic drinks. The workers form an impromptu party and get drunk while hidden by the containers that they are supposed to be unloading. The potential for concealment that such containers provide is here disrupted by a kind of carnivalesque inversion. Workers exercise their subjectivity by secretly withdrawing their labour and using the very technologies which extract value from such labour as a kind of camouflage for their subjective resistance.

Something similar is recorded when the dock-workers address the topic of illegalised migration. The narratives that they tell of undocumented labour are contradictory: on the one hand the dockworkers claim that immigration services are 'very good' at catching 'illegal immigrants'; on the other hand the colourful stories that they tell speak of an excess

1734
Insurrection on the ship Ferrers Galley. Nearly 80 are killed, many by jumping overboard.

1735
Planned uprising in Antigua discovered: 86 are executed

1736

1737
Hundred African captives jump overboard when Bristol slaver The Prince of Orange arrives in St Kitts. Most were recaptured, but 33 drowned

1738

1739
Maroons in Jamaica win freedom, after years of guerilla warfare.

1740

of migrants who have been 'running all over the place'. The disjunction between these two versions may simply be a response to officialdom which demands censure for its activities. Alternatively, it may be that the dockworkers are themselves subject to the popular discourses of illegalised migration, which tend towards images of immensurability and uncontrollable flow, in the face of its actual containment. What is undeniable is that the stories that are told contain narratives of migrants disappearing from the dock with apparent ease. One example is particularly relevant to the idea of labour's invisibility and it renders the migrant worker in particularly ghostly terms. Describing how illegalized migrants are usually encountered, a dockworker explains:

"They hide everywhere. Normally you come in you find a trailer with the curtain ripped open. You find an empty packet of cigarettes, and some old clothes and no sign of them, they're just gone."

In this story, the representation of illegalised migrants is possible only by tracing their absence. Embodied labour is 'visible' in the space that it creates in containerised global transportation. The disruption of the sleekness of contemporary logistics serves as a testimony to the presence of labour as a component of consumer capitalism. Like the commoditised labour spilled onto Branscombe beach, the body of subjective labour emerges from the very geometries of free trade which seek to conceal its existence. It also echoes the dockworkers' account of their disruption of the movement of capital. Like the drunken dockers hidden in spaces of emptiness within the containers, the migrants here evacuate spaces that should contain commoditized labour, the fetishised concealment of their embodied presence, and subvert the intended purpose of international freight.

This account of the traces of embodiment, as opposed to the visualised body, which mark the presence of subjective labour in its spectral re-emergence, finds its twin in the visual field of the animation which is characterised by what it cannot show rather than what is actively shown.

1741

1742
Revolt in Jamaica put down

1743

1744

1745
Revolt in Jamaica put down

1746

1747

1748

1749
Job Ben Solomon came to England and met Sir Hans Sloane, whom he helped in translating Arabic manuscipts and medals. He returnedtoAfrica in 1749.

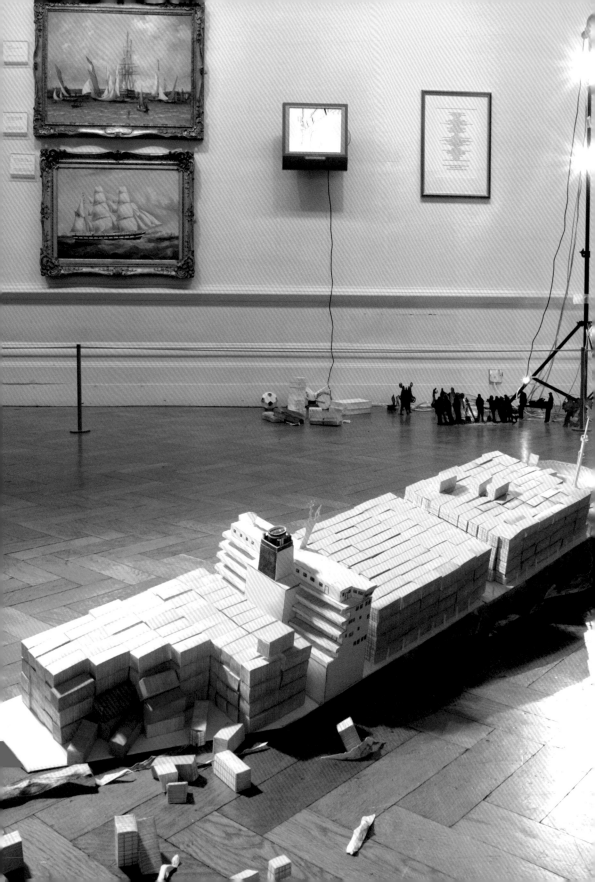

Jackson was allowed to film in the dock areas only if she agreed not
to use the images that she had acquired. In seeking to find a means to
make her footage useable she produced an animated film which has
radically degraded the visual field. The result of her manipulations of
the images is a visual frame that is almost wholly blank. Most of the
frames comprise a white screen with rough outlines of the objects being
depicted. Yet, notably, Jackson's depiction functions as a kind of parody
of surveillance by depicting trucks being surveyed using the sophisticated
electronic equipment designed to detect illegalised migrants. Jackson's
representation of the scanning of the vehicles inverts the surveying
eye and, interestingly, resembles the very images that this technology
produces. Jackson explores the limits of what is visible, and to whom,
by rendering surveillance technologies as visual phantoms at the limits of
the perceptible.

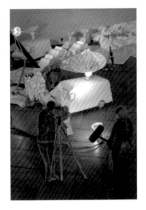

References

[1] Hugo Swire, *Hansard*, (24 March 2009) Column 277-282, Marine Accident Investigation Branch,
*"Report on the Investigation of the Structural Failure of Msc Napoli English Channel on 18 January
2007,"* (Southampton: 2008).

[2] These comments are drawn from a talk at the Hansard Gallery, Southampton, UK, on 17 January
2008 as part of the *Port City* exhibition (27 November 2007 – 26 January 2008), and an
unpublished interview by the author 7 April 2008.

[3] Marcus Wood, *Blind Memory: Visual Representations of Slavery in England and America, 1780-
1865* (Manchester: Manchester University Press, 2000), 25-26.

[4] David Harvey, *The Condition of Postmodernity: an Enquiry into the Origins of Cultural Change*
(Oxford: Blackwell, 1990), 285.

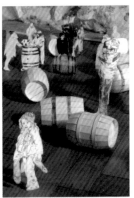

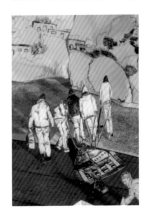

The Undesirables
Melanie Jackson
Etchings, transcripts, animated
sequences DV PAL, sound, 2007
Photographed in the Maritime
Collection Gallery of Plymouth
City Museum and Art Gallery,
2007

Fiona Kam Meadley

"When the Abolitionists were campaigning against slavery in the 18th century, everyone told them that without slavery the economy would collapse..The economic products of slavery are still some of the products of unfair trade.. People often say that's the way the world is. If you try and intervene, our economy will collapse. We want unfair trade to go from being accepted to being seen as beyond the pale."

— Harriet Lamb, Executive Director, The Fairtrade Foundation, 2007

Free or Fair? explored links between present day fair trade campaigners and 19th century Abolitionists, and between fair trade goods and the plantation crops traded through the Transatlantic Slave Trade. By choosing the format of a competition and a publicity leaflet, Meadley adopted the language of everyday consumerism to engage people with ideas about fair trade and reveal the stories behind the production of commodities sold in shops. *Free or Fair?* unpacked how fair trade goods, sugar, chocolate, coffee and tea, are those same plantation crops which were traded though the Transatlantic Slave Trade. Fair Trade is a different way of trading with producers from poor countries, involving buying direct from producers in poorer countries and paying a fair price for products. It attempts to help achieve lasting change across the poorest nations of the world. The leaflet included interviews with Fair Trade campaigners exploring why they campaign and whether they share the sense of personal conviction that drove the 19th century Abolitionists. The campaign for Abolition was a grassroots movement that slowly changed public opinion over a period of 20 years. Today's Fair Trade movement can be seen as a legacy of that campaign. Meadley interviewed campaigners Harriet Lamb (Fairtrade Foundation), Dudley Tolkien (Plymouth Global Justice Group), Sally Rogerson (Plymouth Quaker Meeting House) and Linda Gilroy (MP for Plymouth Sutton). *Free or Fair?* leaflets were

1749
Job Ben Solomon's story is reported in the pages of the Gentleman's Magazine, 1749. He was captured from Guinea in 1731, and transported to Maryland. He spoke and read Arabic. He came to England and met Sir Hans Sloane, whom he helped in translating Arabic manuscipts and medals. He returned to Africa in 1749.

1750

1751

1752
The Royal African Company is wound up

1753
Africans on board the Adventure seize the ship and run it aground

Free or Fair?
Fiona Kam Meadley
Leaflet cover, 2007

1754

1755

1756

1757

1758

1759
The new Sultan of Morocco, Sidi Mohammed, signs a peace treaty with the British, ending 144 years of slave raids on Britain.

1760
Tacky's rebellion in Jamaica continues for several months; 60 whites, 400 rebels killed.

1761
Tacky's rebellion in Jamaica ends violently: 100 rebels executed.

The London meeting of the Society of Friends advised all Friends against trading in Negroes

distributed through the Plymouth Fair Trade Network and South West Co-operative Society, as well as local shops and cafés, and the Museum's networks. Entrants were invited to match campaigners to interviews, write about what the 'Treasure Map' meant to them, and nominate a product they would like to become Fair Trade. Manufacturers were contacted to tell them their products were nominated by the people of Plymouth. Prize winners were awarded hampers of Fair Trade goods and every entrant received Fair Trade chocolate and a set of stickers explaining the 'Treasure Map'. A public prize giving event was held at the Museum on the closing day of the exhibition. (ZS)

. . .

Zoë Shearman: *Free or Fair?* adopted a participative format, a competition. What was your intention in taking this approach?

Fiona Kam Meadley: I envisaged the project as a 'subversive' intervention. It functioned in a similar way to the competitions used by retailers to persuade us to buy new products and in return for entering, people win prizes. But *Free or Fair?* demanded time and thought, and encouraged people to shift their consuming to Fair Trade products. Entrants had to digest facts and figures, and work things out. This runs contrary to dominant popular culture, which tends to be about instant gratification and encouraging us to become passive consumers.

ZS: The project was developed through a process the centre of gravity of which was out of the institutional context of the Museum. Why did you choose the 'territory' of the shopping mall?

FKM: It made sense to the project that it functioned in the wider social realm and in relation to everyday consumerism. I spent a lot of time walking around Plymouth's shopping centres giving out the leaflets. They are fascinating places, as part of social and cultural anthropology.

— Opposite Page

Free or Fair?
Fiona Kam Meadley
Edition of 4,000 competition
leaflets, 2007 (details)
Research, text and drawings by
Fiona Kam Meadley
Designed with Chris J. Bailey

1762

1763
Rebellion in Tobago

1764

1765

1766
Work starts on the last British fort to be built on the coast of West Africa, at Beyin.

1767
Jonathan Strong is prevented from being sold back into slavery. Strong was defended by Granville Sharp, who successfully demonstrated that he had been freed.

1768

Senegalese fishing boats have become the preferred method of transport for illegal migrants trying to reach the Canary Islands

No official figures are available. Slavery is banned in most countries. Contemporary data is available from: www.fairtrade.org.uk www.antislavery.org/2007

1900-2000 **2000-2100**

map

● 16th century

• Enslavement was sanctioned by law and custom.

• Slaves tended to be a by-product of war, rather than a primary objective.

• Muslims could not be enslaved, but the enslavement of non-Muslims was accepted as a proper method of conversion.

Gossypium hirsutum (upland cotton)

Saccharum (sugar cane)

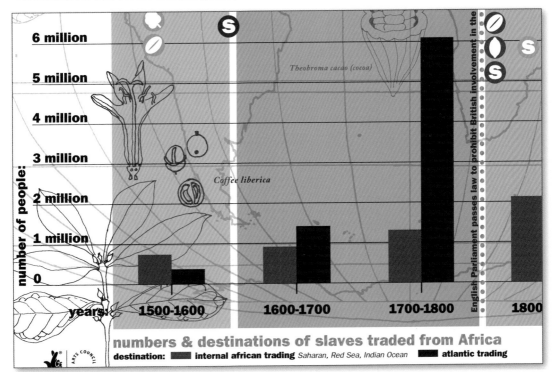

Theobroma cacao (cocoa)

Coffee liberica

number of people:

6 million

5 million

4 million

3 million

2 million

1 million

0

years: **1500-1600** **1600-1700** **1700-1800** **1800**

English Parliament passes law to prohibit British involvement in the

numbers & destinations of slaves traded from Africa

destination: ■ **internal african trading** *Saharan, Red Sea, Indian Ocean* ■ **atlantic trading**

ARTS COUNCIL

To develop a project that entered 'public' space and tried to challenge people's pre-conceptions, was interesting to me.

ZS: The invitation you made to people, to take part in the competition, engaged them in thinking actively about their own personal implication in the mechanisms (and unfairness) of trade through everyday consumerism. Could you talk about the nature of the conditional relationship between consumerism and unfair trade, past and present?

FKM: I was interested in how taking part in the competition might shape people in the future. The connection I was trying to make was between slavery and the goods of slavery – the products. By the beginning of the 19th century, the Slave Trade in Africa has assumed gigantic proportions due to the demand for slave labour to establish the plantations. As Paul Lovejoy has highlighted, slavery became more prevalent wherever the export trade was important. Although the Abolitionist movement reduced the export of slaves, the exporting of other commodities led to an increase in domestic slavery, due to an increased demand for labour to produce export commodities. Slave labour established plantations of cotton in America; sugar in the Caribbean; and coffee and cocoa in Africa. With the rise of industrialisation, production became increasingly mechanised, and wage labour replaced slave labour but agricultural production in African remains largely in the hands of small-scale farmers using labour intensive methods. Their bargaining power is limited and they are subject to unfair competition from subsidised farmers in the industrial world. Now there are laws against slavery in every country in the world but it still exists illegally. The EU estimates 0.5 million illegal migrants enter Europe each year. Being illegal, they are vulnerable to exploitation and many are recruited by Mafia type organisations. The profits of human trafficking and forced labour are estimated in the region of £15 billion. Is modern slavery less visible now it is illegal?
Fair Trade and ending slavery are both campaigns to make a fairer world. As in the 18th and 19th centuries, the contemporary anti-slavery

1769

1770

1771
Thomas Lewis prevented from being sold back into slavery. Lewis was defended by Granville Sharp, who successfully demonstrated that he had been freed.

1772
The James Somersett case: he was an escaped and recaptured slave, discovered on board ship in England about to leave for Jamaica. Somersett is defended by Sharp, who argues on Somersett's right to freedom even though slavery was not unlawful in England.

Lord Mansfield rules on slavery in England. The ruling states that nobody brought to England could be sent back to the colonies against their will. Its effect is to outlaw slavery in England, even though that wasn't its intention.

movement relies on a combination of advocacy and action from organisations such as Anti-Slavery International and wider society. The general public signed petitions and rallied in support of abolition then and continue to do so two hundred years later to eradicate modern forms of slavery such as bonded labour, forced labour, child labour, descent based slavery and trafficking into forced labour. So the connection between slavery and its products continues with the goods we consume today, many of which are produced by people who are not receiving a fair wage. But we, as a consumer society, don't tend to make that connection now. We are removed from it.

ZS: What products did entrants nominate as those they most wanted to see made available Fair Trade and what did their choices reveal?

FKM: From 'everything', to nappies, tampax, local milk and eggs, sweets, Mars Delight, clothes and wooden furniture. A number of people nominated local produced products, such as milk and eggs, and these people felt strongly that the small farmers in Devon and Cornwall are struggling to make a living. I passed the nominations onto the Fairtrade Foundation, who say they have to focus their resources on producers in developing countries. Although they share the concern for farmers in Devon and Cornwall, they take the position that reform at home is someone else's battle.

ZS: The competition leaflet re-presented complex information about global trade. Do you think its denseness discouraged some people from participating and, if so, what is your view on that?

FKM: It seems that some people read the leaflet and tried to answer but gave up, but from those who did enter what we got was passion! This outcome mirrors the lessons of history – the committed few are the catalysts of change. The 18th century abolition campaign was spearheaded by a few committed people who kept that flame alive

1773

1774
Major uprising in Tobago: captured slaves are burned alive, or have their hands cut off.

John Wesley publishes 'Thoughts Upon Slavery'

1775

1776

1777

1778

1779

1780

for years till it finally caught on. Why was it so difficult to identify who said what (a question in the competition)? Because campaigners share common characteristics, whether 18th century or 21st century. The 'Treasure Map' was an attempt to track the changing form of economic domination, market distortions, call it what you may. The campaign against these injustices also continues – Fair Trade being one.

. . .

"The 'Treasure Map' shows the relationship between trade in people and trade in products. The keys for cotton, coffee, cocoa and sugar seem to appear as part and parcel of the map, contributing to and being allowed to continue because of the corresponding rise in the level of slaves traded from Africa. The map refers to the treasure for those benefiting from the trade – sugar and coffee are rich and luxurious symbols of extravagance of the wealthy that benefited from the exploitation of the slaves.

The Slave Trade as an 'industry' was worth untold fortunes. For the slaves traded, represented here as merely figures in a bar graph, there is no treasure. For the period 1900-2000, where official figures are not available, there is a sceptical and ominous undertone implying that slavery still exists, in one form or another. Slavery is still the third largest money-making 'trade' in the world. And for the contemporary period – many of our 'treasures' are still based on the exploitation, know or unknown, of people, communities and countries all over the world."

— **Nigel Smith**, Free or Fair? 1st prize winner

"The 'Treasure Map' shows how some countries disgracefully exploited the people and produce of other nations, robbing them of their freedom and their dignity for financial gains. It shows the extent of Human Slavery in the past and also reminds us that, despite its legal end in the 19th century, human trafficking and exploitation continues in our modern society. The map also juxtaposes the exploitation from past centuries with the progression of the Fair Trade movement today. It shows that steps are

1781
Luke Collingwood, the Captain of the slave ship Zong, throws 133 captives overboard. This is said to be necessary to save the crew and the ship because of shortage of water.
He claims £30 per head insurance money.

'Slavers throwing overboard the dead and the dying - typhoon coming on' by J M W Turner, inspired by the Zong case

1782
The letters of Ignacius Sancho are published, two years after his death.

1783
The Zong case comes to court twice, thanks to the efforts of Olaudah Equiano, the African writer, and Granville Sharp. The case hinged on the insurance issue, not murder, since the

being made to improve the fairness of trade, but indicates that it is still necessary for governments and producers to change their ways to make trade more fair. It also reminds us as consumers, that we all need to do our bit and buy Fair Trade goods. In order to make a change, people have to show their beliefs by buying Fair Trade, indicating their feelings and commitment by voting with their wallets."

— **Adam Ferguson + Victoria Milford**, Free or Fair? 2nd prize winners

"This is a map of the whole world, and a problem which touches us all. It shows just how unfair the world trade system is and has been for centuries. In our attempt to exploit the world's most luxurious natural resources, the cost has been high and meant the course of millions of lives have been unfairly altered or destroyed. Contemporary thinking about Fair Trade is encouraging. It gives the ordinary person a chance to make a difference by simply buying their daily tea and coffee from specialist producers in the full knowledge it was produced by a free person."

— **Daniel Phillips**, Free or Fair? 3rd prize winner

Free or Fair?
Public competition prize-giving event at Plymouth City Museum and Art Gallery
24 November 2007

Left to right: Victoria Milford, 2nd prize winner; John Riley, Plymouth & South West Co-operative Society; Lisa Cheung; Linda Gilroy MP; Fiona Kam Meadley; Nigel Smith, 1st prize winner, and son (front)

captives were considered as cargo. The publicity highlights the inhumanity of the slave trade.

American War of Independence: British defeated. 3000 ex-enslaved Africans, having assisted the British forces in exchange for their freedom, are relocated to Nova Scotia.

1784
A pamphlet is printed by the London Meeting of the Society of Friends. It was titled "Care of Our Fellow Creatures, the Oppressed Africans". 400 copies were printed for distribution to the great and the good in Plymouth.

1785
At Cambridge, Thomas Clarkson writes an essay about slavery. Its subject is: Is it lawful to make slaves of others against their will? It is published and creates great interest, not least in William Wilberforce, MP

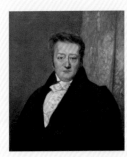

Oh, For the Head of a Monarch
or Maybe it is All About the Money

Raimi Gbadamosi

Moments of Quiet

"Old pirates, yes, they rob I;
Sold I to the merchant ships,
Minutes after they took I
From the bottomless pit.
But my hand was made strong
By the hand of the almighty.
We forward in this generation
Triumphantly."

— Bob Marley, 'Redemption Song'[1]

I was at the National Maritime Museum for the International day for
the Remembrance for the Slave Trade and its Abolition in August 2007,
Jah Shaka Sound System had been invited to perform a dub session for
the occasion. At the end of the night he solemnly played Bob Marley's
Redemption Song. The revellers stopped dancing, sang along, almost as
if in prayer. Then silence.

Jah Shaka rewound, to roars of approval, more voices joined the
chorus this time, and the session was over. It had been a good night.
There was talk of 'arrival', having Jah Shaka at The Maritime Museum
meant something, his sound system had actually rattled the museum
and shaken the collection, and Jah Shaka had been asked to turn it down
and reconfigure the speakers. The symbolism of having a dub session at
the National Maritime Museum was not lost on anyone, it was a musical

1786
Olaudah Equiano is employed by the government to assist in buying supplies for the three ships setting out for 'The Land of Freedom', in Sierra Leone.

Olaudah Equiano was also known by the name 'Gustavus Vassa'

1787
While in Plymouth, Equiano is sacked from this job, after disagreements with the ships' agent, Joseph Irwin. He was subsequently commpensated £50 for his trouble.

Committee for Effecting the Abolition of the Slave Trade is set up in London. Josiah Wedgwood designs a medallion with the inscription 'Am I not a Man and a Brother?'

West African writer Quobna Ottobah Cugoano publishes book against the slave trade: Thoughts and Sentiments on the Evil and Wicked Traffic of the Slavery and Commerce of the Human Species. Reprinted three times in 1787.
Hannah More, a Bristol writer and socialite, publishes The Black Slave Trade, which is

confrontation, a delightful clash of elements within British culture, and Britain itself.

One thing struck me about the commemorations of 2007, it was the lack of discussion within popular music, it was resounding by its absence. It corralled the bicentenary's relevance into a section of the population that saw the bicentenary as a celebration of morality, as a form of triumphalism. How does one address the realisation that all of the major programming was in the hands of national institutions (direct beneficiaries of The Slave Trade and the Colonialism that followed)? Representations of what the Slave Trade was, then, and what the many legacies of the trade is now, was determined by those who, in the exchange of power, benefited the trade by gentrifying and normalising the proceeds.

This cannot be a blame game, it would be too easy to point fingers. Blame does not, and cannot address the subtleties of lived experience, as it has the tendency to polarise traumatic situations. But neither can it be a case of letting bygones be bygones (as if memories and consequence can be erased), there is too much pain, and gain, to address, and the lives damaged and enriched by the trade remain with us today. There is yet parity of opportunity for the descendants of those that form the debating sides two hundred years after an Act in 1807 was passed. The inability of those that were the net losers in the debate (This is in the face of arguments that descendants of the enslaved also benefit from the wealth of 'their nations') to determine and decide what happened all that year of remembrance made a difference as to what the year became in the minds of many. It is not that 2007 was not taken seriously, or that the Bicentenary was not worthy of commemoration, there was just a feeling of disempowerment at not being able to speak of one's own understanding that only collective inherited experience brings. No one alive can tell of what it was like to be there at the passing of the Act, nor what it was like for the many Africans who did not know that the Act had been passed in the first place. It seemed the right to pronounce what the lives of Africans will be has changed little over the past two centuries.

distributed by the Abolition Committee.

1788
Clarkson visits Tiverton, Exeter and Plymouth in November

A bill put forward by William Dolben, MP, is passed by Parliament. The bill regulates the number of slaves a ship could carry, but draws attention to the conditions on board slave ships.

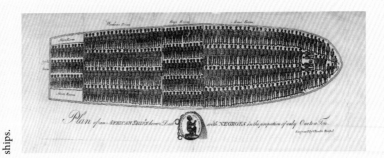

Time Traveller I

I Diallo, move with the wind, haunted by my own longevity. I spy what should be a ghost reflected, and stare back. My memory is alive, it holds what I have seen. I recall looking back towards Saran, my beloved, all those centuries ago, asking her:

"What does the white man want? Does he seek gold or our very selves? Does he only simply desire all he can take? No matter what we do, we cannot satisfy him. How much gold does a people need? We give all we can, then they ask for more." She looked at me saying: *"They want it all, my love. They want all there is to take. I hear that they are hankering for people as well as gold to take away, it seems gold is not enough."*

I protest, *"We should stop them with their own guns, save ourselves from what is to come. This will not end well. I know I will see the disaster with my own eyes, and knowing this does not please me. We may never get over this. We allow all we value to be taken away from our shores, accepting vanity and destruction in return. I hear they make coinage out of our gold. What we pay for in lives, they buy things with. It is so cheap to them."*

"Saran, what will become of our children? I can only watch from afar. As the times roll by, they can never, will never know that I watch over them. To live through the ages allows us to see too much, it means loss. To know that I will watch our children die, tears me apart. But I will tell you all I see Saran, I will let you know what happens. They have taken our land, Saran, all we produce, they plunder our resources, they have even taken our bodies. We have to hold on to our souls, or they will be gone too."

"Diallo means bold, my love, you have been named well. It will carry you."

I hear the British passed a law in their land. They have decided to no longer trade in the people of our land. I hear they do not sell their own people the same way they sell ours. But they are coming over to stay, they say they come to protect us, but it is to take over our land instead. They find it profitable to take all they want from here back to their own

Plymouth Abolition Committee publishes pamphlet with plan of the Brookes slave ship. The plan was initially drawn in Plymouth to illustrate what the allowed space of 'one person per ton of ship', as specified in Dolben's bill, actually meant. It becomes an iconic and influential image.

George Morland produces a number of paintings about slavery. They become popular as prints by John Raphael Smith.

1789
Olaudah Equiano publishes a book about his Life: 'The Interesting Narrative of the Life of Olaudah Equiano, or Gustavus Vassa the African'. It is translated into German, Dutch and Russian.

William Wilberforce tables a bill to abolish the slave trade. The pro-slavery lobby in parliament get the bill referred for examination of a Select Committee, which sits of two years.

land. I hear they make our people pay taxes where taxes did not exist, in their own coinage, that our people cannot afford, I hear they imprison our people using their own laws. I hear they kill those resisting imprisonment, I hear they now make slaves of grown men without even needing shackles.

I hear a great deal, and it is not good news. Saran, what will I be without you to bring me joy?

Saran, times have changed in this new millennium. Now when they say Guinea gold, they mean something cheap, brass with copper to make it red, that they use for plumbing pipe and cheap jewelry. I know we will never see our gold again, it has enriched their lives, and disappeared.

A Proposal for an Installation
The first machine made gold coin in England was One Pound Sterling, dubbed 'the guinea' in recognition of the source of the gold used to mint them. The Royal African Company, a slaving company, was chartered by Charles II and charged with importing the gold for minting the guinea, and earned the right to put their symbol of an elephant and a castle on each minted coin. The guinea was produced between 1663 and 1813, having been made legal tender by a Royal Proclamation on 27 March 1663.

The amount of gold extracted from Guinea allowed for the British production of coinage on an 'industrial' level. The use of a precious metal in coinage tells of a surplus within a nation, in the same way silver extracted from the 'New World' allowed the production of silver coinage in Spain and its neighbours. The guinea was worth twenty shillings, even though the fluctuating price of gold altered the real value of the coin.

The guinea went through many changes through the one hundred and fifty years of its life, but its basic form was the head of the reigning monarch on the obverse, and some arrangement of the arms of the nations the monarch lay claim to on the reverse of the coin. Whilst not on all coins; an elephant or an elephant and castle was incorporated in the design of the coin's reverse.

1789
Storming the Bastille in Paris, signalling the start of the French revolution.

1790
While in Plymouth, Clarkson tracks down a seaman, Isaac Parker, who described slaving atrocities in Calabar and Bonny, South-East Nigeria. His testimony helps the arguments against the pro-slavery lobby which imply that "the voyage from Africa to the West Indies was one of the happiest periods of a negroes' life".

1791
William Wilberforce speaks to his Abolition bill on 19 April for four hours. The motion was defeated by 163 votes to 88.

The revolt in St Domingue, starts on 22 August. The revolt lasts for two years, pinning down French forces. About 5000 French soldiers are killed.

Rebellion in Dominica. The rebels succeeded in evading authorities for four years

Boycott of sugar begins in Britain with publication of a pamphlet 'On Abstaining from the Use of Sugar" by William Fox. This is more effective as publicity than financially, since it coincides with an increase in the price of American sugar.

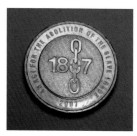

*AM I NOT A MAN
AND A BROTHER*
Commemorative £2 coin marking
the Bicentenary of the Abolition
of the Slave Trade in the British
Empire, back and front, designed
by David Gentleman.
The Royal Mint, UK, 2007

In 2007 The Royal Mint issued a commemorative Two-Pound Coin for the Bicentenary of the abolition of the Slave Trade in the British Empire Act of 1807. On the obverse of the coin rests the head of the reigning monarch, and on its reverse is the number 1807, the zero being a broken link in a five-link chain. The design was made by a Mr. David Gentleman, and is supposed to symbolise a break in the chains of oppression.

Mr. Gentleman said of his design:

"Although I found many historic images of slavery interesting, I was primarily inspired by the power the 1807 Act had on effectively abolishing the slave trade. As such, rather than focus on an image of slavery, my design emphasises the release from subjection and freedom brought about by the Act of Abolition."

It is not without a mirroring sense of irony and an overshadowing of history (an absence of any mention that Britain was a major part of the Trade, means that Britain simply stands as liberator of the enslaved) that Andy Mitchell (Director of Collector Coin Marketing) said:

"The lead Britain took in outlawing the slave trade was an example followed by many other countries and the 200th anniversary is an opportunity for us to commemorate this important advance in freedom. [...]"

The commemorative coin was unsurprisingly named 'AM I NOT A MAN AND A BROTHER', and went out to the British Public as yet another medium of exchange. Not knowing of the launch, I simply received one of the coins as change and had to deal with the fact that here was another manifestation of the bicentenary. And then the irony of it all struck me. Here was the head of the queen alongside a pointer to slavery. The enslavement of Africans was still making money for the British crown. The coin was released in a range of materials; 1000 gold coins, 10,000 silver coins, 100,000 brilliant uncirculated base metal coins (all of which are sold at considerable profit), as well as legal tender coins.

1792
Wilberforce introduces new bill to abolish the slave trade. It is amended by Henry Dundas, to abolish the slave trade 'gradually'. This version was passed by the Commons, but blocked by the Lords.

1793
France declares war on Britain.

The revolt in St Domingue, successfully completed. 500,000 slaves are emancipated

1794
National convention in France formally frees all slaves in its empire. This allows the British pro-slavery lobby to point to abolitionist activity as sympathy for the enemy, thus a form of treason. Lord Nelson argues against giving up Britain's West Indian possessions.

British forces invade St Domingue, but get bogged down in guerilla war against the forces of Toussaint L'Ouverture.

While the similarities between the guinea and the commemorative two-pound coin may be deemed incidental, their relationship to the Trans-Atlantic Slave Trade is clear. They are both worth twenty 'shillings' and find meaning around human exploitation. The disconcerting alignment of the dates the guinea was produced till, to the 'official' end of the trade in people, should not be ignored.

But this is a proposal for an artwork, to install two hundred Two-Pound coins in a gallery. It is an idea to confront and confound a British audience with something they are familiar with and actively choose to ignore the complications of all it stands for. It is not a discussion on the value of money and representations of the other. Nor is it a treatise on the place of coinage in the value of human life. It is representing the difference between a ransom and a price. Oddly enough, the concepts have so much in common when it comes down to it, that one could very easily replace the other. A ransom is a sum of money or other payment demanded or paid for the release of a prisoner; while a price is the amount of money expected, required, or given in payment for something. I look at the Two-Pound coin and it stands somewhere between a price and a ransom. I know I am supposed to be pleased that The Royal Mint saw fit to make a commemorative coin, yet there is something, not quite right, that rankles about the coins.

Maybe it is the fact that the coin gives a very simple version of history, perhaps it is that slavers become liberators by simply stamping out a coin, perhaps it is that there is still money to be made on the back of those enslaved. It may be that the imagery the coin presents is of a clear transition from enslaved to free, while the act of 1807 was not intended to free the enslaved at all. Maybe it is the prominence of celebrations by a few people incapable of understanding the complexities of an argument which goes beyond the desirability of reconciliation (difficult when dealing with what it means for net human and material wealth to pass from one part of the world to another), meaning that two hundred years after the 1807 Act of Parliament, material imbalances are such that there is still talk of a slave/slaver mentality within international trade and political relations. And then a coin is minted.

1795
Uprising in Dominica is crushed, but many rebels evade the authorities.

Major uprising in Grenada. British forces engaged in fighting with rebels.

Samuel Taylor Coleridge delivers lectures on religion and slave trade in Bristol; they are published in the Watchman

Maroons in Jamaica attack British forces. Some Maroons seek peace agreement, but the Jamaican governor reneges on this and arrests them. They are transported to the British colony in Nova Scotia.

Revolts in St Lucia, Guadeloupe, Trinidad. British troops brought in to quell them.

1796
Major uprising in Grenada continues. British forces engaged in fighting with rebels for several months

My Song

What I feared happened, the large institutions got all the money, they put on shows and exhibitions that gave the right impression of what Britain feels about the Trans-Atlantic Slave Trade, and nothing much changed for the bearers of the legacy. Of course artists had commissions, some permanent pieces now exist that recognise the Trade, but even these are neutered by their place and origin.

Tunneling By Numbers
Raimi Gbadamosi
2007

If it is accepted that individuals have a Residual Self Image, then the collected people that form a country will have a Residual National Image. The British Residual National Image is one of some complexity, including qualities such as: fair play; the rule of law; democracy/parliament; mutual respect; tolerance; restraint; fairness towards minorities; obligation to civil institutions; and the list can continue. The Trans-Atlantic Slave Trade complicates this self-image with the realities and cruelties of

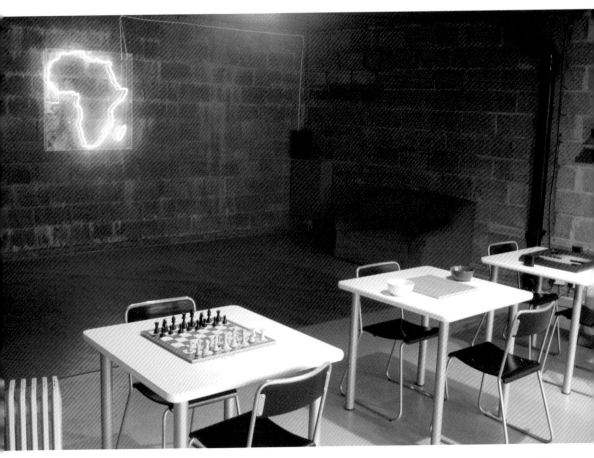

Shrine
Raimi Gbadamosi
2005

— *Above*

Personal Person
Raimi Gbadamosi
2005

Transactions of Desire
Raimi Gbadamosi
2009

national trading in humanity, and 2007 only seems to have forced this complication to the fore. The simultaneous acknowledgement/denial of what the Slave Trade means to Britain's historical status and present abilities in the world has led to the schizophrenic responses to the Bicentenary. Up and down the country attempts were made to not ignore the awfulness of the Slave Trade, while attempting to maintain and highlight the possible 'positive' consequences of silencing and sharpening a national moral compass.

In The Telegraph, 'Ten Core Values of the British identity'[2] appeared on their comment page in 2005, eighteen months before the Abolition parade began. Listing these values as: the rule of law; the sovereignty of the crown in parliament; the pluralist state; personal freedom; private property; institutions; the family; history; the English-speaking world; and the British character. The last one is worth reproducing in full:

X. The British character. Shaped by and in turn shaping our national institutions is our character as a people: stubborn, stoical, indignant at injustice. "The Saxon," wrote Kipling, "never means anything seriously till he talks about justice and right." [3]

Given that this is what the British character is supposed to be, it does not bode well for justice, especially as justice is a mutable element, determined by tradition and custom. This makes the lyrical cliché of whether it is 'Justice' or 'Just Us' that 'non-British' people face, when conflicts of interest arise.

The use of free labour under bondage still continues today, and not on far-flung outposts beyond the reach of law and policing. But in Free Trade Zones, enshrined in the boardroom rhetoric of Liberal Economies. The right to profit has become so sacrosanct as to trump almost all arguments of humanity and decency. So using terrorism as a pretext to list that which sets out an undated and timeless argument of what Britishness amounts to, the inventory's author inadvertently set the parameters of what will be simultaneously celebrated and protected in two years to come.

1797
Major uprising in Grenada: 5000 British needed to restore order after three years of rebellion

London Committee for Effecting the Abolition of the Slave Trade suspends operations.

Britain seizes Trinidad from Spain.

Wilberforce tables the Slave Trade Abolition Bill. It is voted down.

1798
British forces withdraw from St Domingue. Toussaint L'Ouverture's forces are victorious.

Wilberforce tables the Slave Trade Abolition Bill. It is voted down.

1799
Wilberforce tables the Slave Trade Abolition Bill. It is voted down.

1800
Wilberforce tables the Slave Trade Abolition Bill. It is voted down.

Subsequently, in 2007, the British Parliament had a direct opportunity to celebrate what it felt was good about Britain in general, and Parliament in particular, (it was presented over and over again that it was the British Parliament that brought the trade in slaves to and end. This, and not the embarrassment of collusion was highlighted in 2007) and it went to town. While it may appear churlish to point out that the very same parliament had legislated on much of the minutiae that determined and allowed for the transport and trade of people, it becomes necessary to note this fact when one questions the strategies employed in the commemoration year, it is clear that the funding released for events up and down the country was a cultural sacrifice, with atonement, pacification, and erasure as unspoken goals.

Contemporary slavery therefore became the acceptable foil for what had become an embarrassing continuum of a travesty. It was possible to maintain indignation about slavery, slavery being the focal point, while evading all responsibility attached to being an enslaving nation in the past,

The Flag of the Republic
Raimi Gbadamosi
2001

1801
Large-scale rebellion in Tobago is discovered The planners are punished.

Wilberforce tables the Slave Trade Abolition Bill. It is voted down.

1802
Spain passes over control of Trinidad to Britain.

Wilberforce tables the Slave Trade Abolition Bill. It is voted down.

1802-1803
France reinstates slavery in its colonies, overthrows Toussaint in St Domingue. St Domingue forces continue to oppose French.

1803
An Act banning the import of slaves into her Caribbean colonies, passed by Denmark in 1792, comes into force.

Wilberforce tables the Slave Trade Abolition Bill. It is voted down.

1804
At the suggestion of Wilberforce, the London Committee for Effecting

a considerable beneficiary of enslaved people's labour in the present, without the nation collapsing in on itself.

2007 was a master performance on how to forget what ought to be remembered, so that it will not be repeated by remembering what ought to be forgotten, in order to not address what is in front of us.

Time Traveller II

They use our name to insult themselves now, grown men fight over being called Guinea. To be associated with us is to be denigrated. In their desire to align themselves with the enslavers, they find offence in the possibility of being called black, they believe that to be called black is the same as being a slave. I would laugh at them, if the joke was not on me.

Saran, they now shoot us in the street like dogs with guns much better than they left us. They have definitely improved on the many ways to define and destroy our bodies. They have even found the means for us to do the killing for them, yet again. They hold trials in their courts over our murders and declare themselves innocent of crime. They shoot us in our homes, and we die needlessly to meet their new needs to control our dreams of what we want to be.

Saran, do you remember that law the British passed in 1807? They now celebrate their own largesse. Two hundred years already. It is a strange event to watch. If I had not been there, in the beginning, I too would have been sucked into this purposeful display. They have done well with the gold in the meantime, there is a surplus available to make merry. They have even made a special coin with the head of their queen on one side, and chains on the other to mark the moment. I cannot but feel it is their perceived might and our assumed servitude being represented. I scream in my head: 'we are not limited to the bindings you forged, we are not what your imagination produces.' Their people celebrate the humanisation the 1807 Act brought them. A paradox, when I consider what the Act says. The white people have somehow all become liberators, while black people can only assume the role of slave and first-level slaver. Like some national game of 'Cowboys and Indians' (with all the linguistic, cultural,

the Abolition of the Slave Trade reforms. It acts as a parliamentary lobbying group, rather than a pressure group.

Wiberforce once again tables the Abolition of the Slave Trade Bill. It is passed by the Commons but stalls in the Lords

1805
The Abolition of the Slave Trade Bill is stalled in the Lords

1806
James Stephens tables the Foreign Slave Trade Bill. It is passed into law. The Act bans British involvement in the slave trade with France and her allies; it is presented as a measure to help defeat the enemy.

1807
Act for the Abolition of the Slave Trade is tabled. It is passed by the Lords and the Commons; it becomes law on 25th March. British parliament outlaws British involvement in slave trade from Africa to Americas.

1808
Freetown, Sierra Leone, is taken

racial, and genocidal implications of this childish parody of Manifest Destiny), I can but watch a set and unquestioned narrative being played out.

Some things seem to have changed for the better for our children, at least on the surface. It as if the past were a made-up story sometimes, rather than a reality lived by all. Some things have remained the same though, especially in dialogues of power, no pretense there. I watch the new histories being written with trappings of concern and good intentions, yet it is still an imposition. But then, it's their own party, and they should be allowed to choose the music. Spoke to Guinea by telephone (over a century of using the thing, and it still feels strange), no one seems interested in bicentennial events there. It seems that when the British left in 1887, they ceded more than land.

"Is that all it has been Saran? One hundred and twenty years since they left? What of those stories and rumours of John Lok and James Gray being the ones who started the taking? Imagine the honour of that? These two are credited with taking five people from Guinea in 1555, and the gold soon followed. I know there must have been those before those two, but the British like their records and laws, and they passionately defend the way their records and laws allow them to keep on taking. I can only laugh at how the taking allows the recording and lawmaking to carry on. Saran, the telling of justifying stories follows, and they abound. Now they blame us for the taking, they have made us all collaborators, they say we gave all we had for what we wanted. What am I to say to my accusers?"

References

[1] Marley, Bob. 'Redemption Song' on Uprising, Island Records 2001.

[2] Comment 'The Telegraph' 27 July 2007.

[3] Comment 'The Telegraph' 27 July 2007.

over by the British Crown, to be used as a naval base, for two ships to patrol the West African coast.

1809

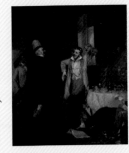

1810
'An Unexpected Visitor' by Robert Haydon, about 1810

1811

1812

1813

The Human Cargo Project

Len Pole

As a student of social anthropology in the 1960's I was only dimly aware of the baleful and long-drawn out story of the Transatlantic Slave Trade. We learned a lot about African kinship, political and economic systems, but it was as if they existed in an historical vacuum, coyly referred to as 'the ethnographic present'. I was awakened to the extensive and insidious proportions of the trade thanks initially to a lecture from Philip Curtin in Accra in 1971. I worked at that time at the Ghana National Museum, which was and is administered by the Ghana Museums & Monuments Board. I was aware of the presence of the many European castles and forts along the Atlantic coast, their dark and damp chambers, and the stories locked in them that required to be told. Although the GMMB put an exhibition together in the infamous Cape Coast Castle in 1972 about its history, by present-day standards it did not do justice to the subject. It has since been expanded and updated. It is unfortunately true that, with one or two exceptions, it was only in 2007 in the UK, with the 200th anniversary of the passage of the Abolition Act through the British parliament, that the museum sector has begun to grapple with this shameful and woefully ignored aspect of British history.

At the end of 2005 the Plymouth Museum initiated a process of confronting these under-researched histories, not only within Plymouth, but for the wider community in the south-west. From the outset, Plymouth had understood the importance of engaging more than a single voice in the preparation of the exhibition, so had planned to use co-curators and artists, to incorporate multiple approaches to the subject.[1]

One of the things that became obvious when ideas for the 2007 exhibition were first discussed, was that this was going to need a programme of local consultation. This was undertaken with as many elements of the local community as possible, not just black and minority ethnic groups, to understand more about where we were starting from. It resulted in a report

Gold weights
Copper alloy, for weighing gold dust. Ghana. 17th to mid 19th centuries. Plymouth City Museum and Art Gallery

Sugar and pepper casters
Silver, made by Samuel Wood, London. 1742. Plymouth City Museum and Art Gallery

1814
Inhabitants of Plymouth consider petitioning the Prince Regent concerning the renewal of the horrors of the Slave Trade. People were concerned about the use of British capital in continuing the trade, also trading enslaved people into British colonies from French colonies. This was not outlawed by the 1807 Act.

Dominican authorities finally capture last rebel. 578 rebels were killed or captured between 1791 and 1814.

1815

1816
Rebellion in Barbados led by Bussa. Hundreds of slaves are killed or executed. £175,000 worth of property destroyed.

1817
Slave Registration Act comes into force. This Act forced all slave owners to provide a details of the enslaved people they owned every two years.

Portugal and Spain agree a right of search of their ships, but only north of the Equator. This is ineffectual, since most of their traffic sails south of the Equator.

which informed much of the subsequent thinking.

One of the most revealing outcomes of the consultation, although not unexpected, was the lack of awareness of the involvement of Plymouth and the south west in the Transatlantic Slave Trade, its abolition and the legacies. This came up repeatedly in interviews with focus groups. This confirmed the Museum in its initial assumption that it had a responsibility to put an exhibition together which clearly located the city and the region in this story, so that its involvement was clear.[2]

The internal dynamics in framing the exhibition changed as plans matured, particularly with the input of curator and artist Raimi Gbadamosi. He drew in the whole range of collections in the museum to encourage visitors to realise what the material and economic consequences of Britain's involvement in the slave trade were for everybody who lived in Britain from the 17th century up to the present-day. There was also an increasing realisation that the time line would need to be a key integrating element, rather than just a kind of index, so that it became a feature that linked the legacies with an over-arching chronology. At the same time we needed to work through a less literal historical framework, to emphasize the need to go beyond the more obvious elements of the slave trade story.[3]

There was much discussion throughout the development of the project about how the artists' contemporary presentations should 'sit' with the historical material being presented: it was important that people visiting the museum during the exhibitions understood the chronology of the story, but also that they could feel the impact of the legacies in the present.[4]

It is important to recognise that the south west of England has something distinctive to contribute to the story, which serves to reinforce the extent to which all communities in the British Isles were implicated in it. The inescapable features include the involvement of Hawkins, Drake and other seafarers from the southwest in the development of the trade, plus the contribution of the local Quaker and Methodist communities to the abolitionist cause in the later 18th century, encapsulated in the 'Brookes' image (see page 63). Also the range of ethnographic items linked specifically to British involvement in West Africa, built on legacies of the trade as represented in the 19th century colonial

Manilla
Copper, made in England for the West Africa trade. 18th century. Plymouth City Museum and Art Gallery

Anti-slavery medal
Bronze medal struck to support the involvement of women in the anti-slavery movement of the 1820s. Torquay Museum.

Stool
Wood, made in Kumasi, Ghana. Mid 19th century. Plymouth City Museum and Art Gallery

1818
Freetown in Sierra Leone becomes headquarters of British interests in West Africa. A Court is established.

1819
West Coast of Africa Squadron is established by the Royal Navy, with six ships. Its remit is to suppress the slave trade operated by ships of other countries.

1820

1821

1822

1823
Rebellion in Demerara (now Guyana). Over 9000 thousand of rebel slaves involved; 250 killed. A white missionary, John Smith, is made a scapegoat and sentenced to death. This brings the Church of England to support abolition.

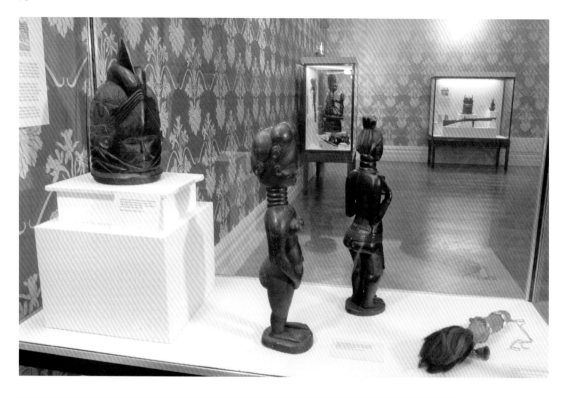

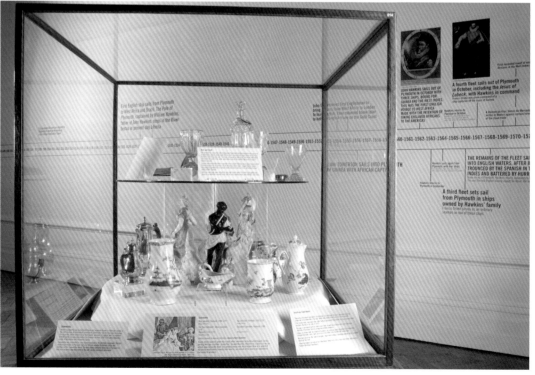

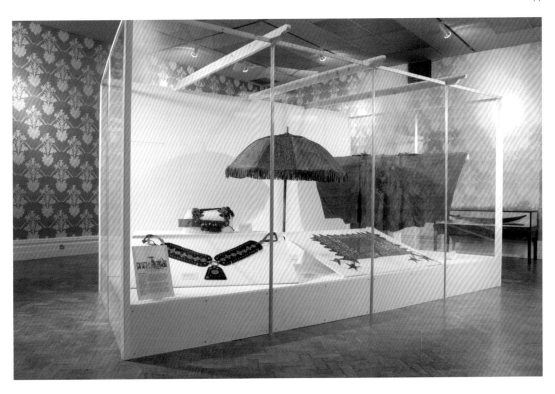

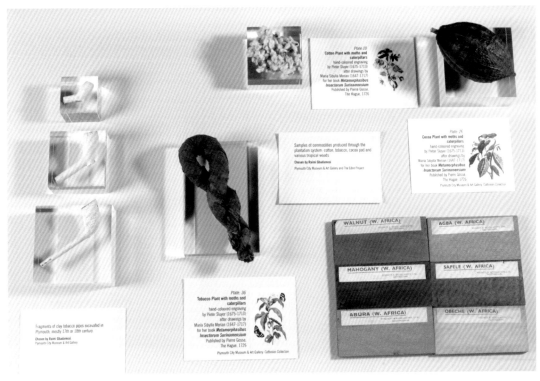

Fragments of clay tobacco pipes excavated in
Plymouth, mostly 17th or 18th century

Chosen by Raimi Gbadamosi
Plymouth City Museum & Art Gallery

Samples of commodities produced through the
plantation system: cotton, tobacco, cocoa pod and
various tropical woods

Chosen by Raimi Gbadamosi

Plymouth City Museum & Art Gallery and The Eden Project

Plate 10
**Cotton Plant with moths and
caterpillars**
hand-coloured engraving
by Pieter Sluyer (1675-1713)
after drawings by
Maria Sibylla Merian (1647-1717)
for her book *Metamorphosibus
Insectorum Surinamensium*
Published by Pierre Gosse,
The Hague, 1726

Plate 29
**Cocoa Plant with moths and
caterpillars**
hand-coloured engraving
by Pieter Sluyer (1675-1713)
after drawings by
Maria Sibylla Merian (1647-1717)
for her book *Metamorphosibus
Insectorum Surinamensium*
Published by Pierre Gosse,
The Hague, 1726
Plymouth City Museum & Art Gallery Cottonian Collection

Plate 36
**Tobacco Plant with moths and
caterpillars**
hand-coloured engraving
by Pieter Sluyer (1675-1713)
after drawings by
Maria Sibylla Merian (1647-1717)
for her book *Metamorphosibus
Insectorum Surinamensium*
Published by Pierre Gosse,
The Hague, 1726
Plymouth City Museum & Art Gallery Cottonian Collection

WALNUT (W. AFRICA)

AGBA (W. AFRICA)

MAHOGANY (W. AFRICA)

SAPELE (W. AFRICA)

ABURA (W. AFRICA)

OBECHE (W. AFRICA)

territories of Nigeria, Ghana (then the Gold Coast) and Sierra Leone. These include such iconic items as copper-alloy pieces looted from Benin City, a wooden stool from Kumasi, the Asante capital, and a silk umbrella taken from a Muslim chief in northern Nigeria.

To a greater extent than with other commemorative exhibitions produced in 2007, the Human Cargo exhibition used the contemporary visual arts installations to challenge visitors to think of the present day forms of slavery and human-on-human exploitation. They were embedded throughout the museum, not just in the area set aside specifically for the exhibition. They encouraged visitors to consider how not only the products of the Transatlantic Slave Trade but its very essence infiltrated itself into the whole fabric of British society, as represented by collections everywhere in the museum, to the extent that the museum itself should be thought of as an artefact of the British colonial enterprise and the trade it is based on.

The need for further research to be done into the local dimension of this story became ever more apparent as this project came to completion, in order to emphasize the involvement of Plymouth and Devon in it, to set against that of Bristol or Liverpool. It is a national story, not just to be associated with 'the usual suspects'. The necessity of this was reinforced by the returns from the consultation, since the assumption that 'it had nothing to do with this part of the country' was commonly related. The corollary of this is that this project should become the first of many in the coming decades which seek to excavate the details of all aspects in the story.

Consequently, upon the completion of this exhibition, it would be good to think that research could be funded and realised as a legacy of this project, to be implemented in the next few years, which would result in the kind of display programme which many have felt was missing from the plethora of exhibitions in 2007.

At a seminar held in Liverpool in November 2007 two of the speakers lamented the opportunities that the museum sector had passed up in its projects to mark 'Abolition 200'. One was Mike Phillips, the novelist, historian and curator who has been involved in Cross Cultural work at the Tate Galleries, and written about the experiences of the Windrush generation in London as an

1823
A new abolitionist organisation is founded, called The London Society for Mitigating and Gradually Abolishing the State of Slavery Throughout the British Dominions. Elizabeth Heyrick's response to this was to publish a pamphlet "Immediate not Gradual Abolition"

Plymouth petitions Parliament for 'the gradual abolition of slavery', presumably in support of the London Society.

Thomas Clarkson goes on the road again

1824
Piracy Act is broadened to include slave trading, but it remains impossible for the Anti-Slavery Squadron to board ships flying other nations' flags - the "freedom of the seas" is paramount.

1825
Women form anti-slavery societies. These include Mary Lloyd and Sarah Wedgwood; also Anne Knight and Elizabeth Heyrick who were Quakers and were used to speaking in public and being listened to.

1826

example of what it is to be Black and British in the UK. His view is that instead of confronting our history in the light of current needs, the network of museum and gallery events in 2007 has been 'a hotpotch of disconnected exhibits which mirror a Victorian racialising of history'. The most significant aim in his view should have been pressure to change things in the battle for civil rights for black people today. Transatlantic slavery was not just about exploitation based on race; it also concerned economics, enlightenment, the development of the British Empire. His point was that the major population migration patterns in the late 20th century result from the effects of the Transatlantic Slave Trade and consequential trading and political relationships up to the end of the 19th century, all of which reverberate in the present day. The chance to explore these historical strands was missed in favour of a re-working of racial issues in the master-slave relationship, so reinforcing the marginality of black interests. Remembering slavery should be a way of understanding how, what and where we all are, now. We should be looking today to the commemorations in 30 years time; to understand what is happening now, rather than 'planning to put objects in rooms to demonstrate historical developments'.

I acknowledge the power of Mike Phillips' arguments. Nevertheless, I am happy to defend putting objects in rooms, not only because this is what people who work in museums do, but because there are stories to tell which up to now have not been told, need to be told and can be told using those objects, whether the location is Plymouth, Liverpool, Ghana, London or Leamington Spa. This applies equally well to 18th century sugar bowls which commonly crop up in decorative arts collections, but are not usually displayed as artefacts of the slave trade, as to the copper manillas made in their millions in England for use in that trade and to the Benin bronze head, the collecting and exhibiting of which speaks directly about the legacies of that trade. It should also apply to artefacts which help to tell the stories of shameful white British attitudes to black and minority ethnic communities in the UK during the last 60 years.

Yasmin Alibhai-Brown, the Ugandan-born writer and broadcaster, author of *After Multiculturalism*, was also critical of some of the exhibitions mounted in 2007. She was worried about it becoming just another 'binge year': if it is 2007 the resources must be directed towards exhibitions about the Abolition

— Previous Pages

Top Right
Left to right: Horse bridle.
Leather, woollen cloth, tin rattles, used on special occasions.
Before 1902.
Umbrella. Covering of silk damask, presented to the Sirikin (chief) of Abuja in Northern Nigeria by the Royal Niger Company. Before 1902.
Saddle Cloth. Woollen cloth, cotton, leather applied patterns.
Before 1902.
Robe. Cotton, with protective amulets, worn by a man. Before 1902. All taken by Lt Pye while he was in action for the West Africa Frontier Force in 1902.
Collection of, and photographed at, Plymouth City Museum & Art Gallery, 2007

Bottom Right
Tobacco pipes,
17th or 18th century.
Cocoa pod and solids, chocolate, cotton, various tropical woods.
Samples of commodities produced through the plantation system. 18th century
Chosen by Raimi Gbadamosi
Plymouth City Museum and Art Gallery and The Eden Project
Photographed at, Plymouth City Museum and Art Gallery, 2007

1827

1828
Plymouth petitions Parliament on 'ameliorating slavery in the Colonies of the British Empire'

1829

1830

1831
France passes an act making the Slave Trade illegal.

Insurrection in Jamaica, inspired by Sam Sharpe, a Baptist Deacon. 15 whites are killed, over £1,000,000's worth of property destroyed or damaged. Over 500 rebels are killed or executed. British troops regained control after two weeks. Baptist chapels were burned down. Sharpe was executed and his owners compensated £16 10s.

of the Transatlantic Slave Trade, but when 2008 comes along it will be something else.

Yes, this is a real fear of what will happen if we in the museum sector are not alert to it. So it is up to museums to make sure the lessons and legacies are not put to one side. But I think if there had been no Abolition 200 'binge', the likelihood is that there would be no basis for further work; this opportunity to continue and develop must be taken up, not left to wither.

As far as I was concerned, it was always clear that the *Human Cargo* exhibition should be the first of an evolving set of events and collabourative projects on this theme. The whole story does need to be researched, understood and told. This will involve developing a realisation that the legacies of the transatlantic slave trade are everywhere, not just in a special exhibition, not just in the museum as a whole, but throughout the city, in other urban centres and not least in the surrounding countryside estates. But not only that: also that black people and the black communities have lived and are still living with the legacies of slavery and the realities of racism on a daily basis.

This exhibition has sought to highlight the unique atrocity that was the Transatlantic Slave Trade, while also placing it as a particular example of humankind's baleful and continuing propensity for propagating evil procedures on its own species. It helps to stress the modern world's complicity in other pieces of the unacknowledged wallpaper – for instance, the appalling living conditions many people across the world have been and are still condemned to endure, at the hands of others who are in positions of economic dominance.

What are the next steps? The inescapable responsibility of these 2007 events should be to make sure that these stories become familiar to present and future generations. We could start by developing its presence in the school curriculum; as much as the Romans in Britain or the Second World War (and perhaps even more than the Ancient Egyptians?). The regular inclusion of Trevor Phillips' Windrush BBC TV series in every citizenship module would be a good start.

Mike Phillips' point was that history of black communities in the UK over the last 60 years is a story not yet told, and has been sidelined by the

1831
Mary Prince, an abolitionist and former slave in the West Indies, has her story published in England. The book The History of Mary Prince, a West Indian Slave, contributed to the growing slavery abolition campaign. She presented an anti-slavery petition to Parliament.

1833
Act to abolish slavery passed. William Wilberforce dies three days after the Act is passed. Although slavery itself is abolished, the ex-slaves are not free, becoming 'apprentices' for six years. Strikes and demonstrations reduced this to four years.

1834
Abolition of Slavery Act comes into force on 1 August. Slave owners are compensated over £20million for the loss of their property. The ex-slaves receive nothing. The Bishop of Exeter, Rt Revd.

Abolition 200 commemorations. This needs to be worked through for the communities in Britain as a whole. That is one goal the next steps will need to achieve. But Plymouth Museum must also keep the needs of its constituency in its sights, as it has taken the trouble to investigate what they are, and cater to them. This is what it began to do in the Abolition 200 project, and hopefully what it will continue to do, while at the same time responding to the broader national agenda.

Telling the more fundamental story, of and for all British communities, is the principal necessity. This means getting to the core of present-day racism and the struggles of black and other incoming communities in this country for their stories to be heard, understood and acted on. It is not just for them that these stories needs telling (they may be sick to death with them) but for the rest of the nation – to be aware of, acknowledge, and transform these continuing realities.

References

[1] Quote from Human Cargo Evaluation Report Executive Summary: In a physical sense Human Cargo infiltrated the museum in ways that were perhaps not originally imagined by the host venue. This integrated interaction between artists, the collections, and the fabric of the museum, flags up the very real potential for the museum itself to be read and interpreted as a historical artefact. The exhibition represents an important opportunity for the museum to reflect upon itself, its own history as an institution, its collections and its potential role in supporting understanding of these histories at the outset of the 21st century.

[2] Quote from Human Cargo Evaluation Report Executive Summary: *Respondents to the evaluation research believed that Human Cargo had been very effective in raising awareness and understanding of Abolition and the Transatlantic Slave Trade, and their connections to Plymouth/Devon in particular.*

[3] Quote from Human Cargo Evaluation Report Executive Summary: *Throughout the evaluation process the timeline was cited as a particular highlight and a linchpin of the project. In interviews with staff and visitors, and through comments books, we find evidence of the impact of this device, described by one respondent as 'an accessible narrative of clearly expressed facts that spoke volumes'.*

[4] Quote from Human Cargo Evaluation Report Executive Summary: *The ... tone of the exhibition was praised for its ability to be 'clear, sensitive and uncompromising in its conviction to make clear the history of the slave trade.' The approach has been described variously as 'objective', 'cool', 'restrained', 'un-dramatic'; and many visitors reported being both well informed as well as being moved by this restrained presentation of the facts and artists interventions.*

Henry Philpotts, Bishop of Exeter, received £12,729 4sh 4d for slaves he had owned in Jamaica.

1835

1836

1837
John Gladstone, a plantation owner in Guyana, was given permission to import labourers from India, later known as 'coolies'. Many Indian labourers ended up working for little more than food and shelter.

1838
Emancipation: period of 'indentured labour' comes to an end on 1st August. The ex-slaves get neither compensation nor access to land to work. Many are forced to work for their former masters for a pittance, and have to pay rent and taxes.

1839
British & Foreign Anti-Slavery Society formed.

An Act is passed to regard Portuguese ships equipped for slaving as if they are pirates.

Human Cargo: an opportunity for participation and collection access

Tony Eccles

"Has inspired further exploration into my Jamaican roots. Thank you."
— Comment from a visitor to the *Human Cargo* exhibition.

Resources and planning

The initial planning for the Human Cargo exhibition came at a time when the Royal Albert Memorial Museum in Exeter (RAMM) had received 10.3 million from the Heritage Lottery Fund to support its structural refurbishment. This meant closing the museum to the public in 2007 until its proposed reopening in 2011, and developing an Out and About programme to maintain some meaningful engagement with its audiences.

During this period of closure, RAMM's ethnography department was awarded £100,000 Designation Challenge Fund (DCF) from the Museums, Libraries & Archives Council (MLA) as part of its 'Opening Up Collections' strategy. This gave the collection a much needed boost towards its conservation, research and display programme; one that was focused on making its collections accessible either through display, publications or the Web. The DCF award reflected many of RAMM's ambitions including the exploration of cultural identity within Exeter and Devon. This was never going to be an easy challenge. However, some of the key projects were successful, to the extent that their legacies remain. This publication is one such example, *Small World: Global Fashion* and the development of RAMM's ethnography collection-based website are others.[1]

It is important to note that without this funding RAMM's contribution to Human Cargo would have been extremely limited. DCF funding allowed RAMM the freedom to decide how much of an investment could be made into projects. Human Cargo was a perfect vehicle for satisfying

1840

1841
Attack by the Royal Navy brig Acorn on a slaver.

'HM Brig Acorn, 16 guns in chase of the piratical slaver Gabriel, 1841

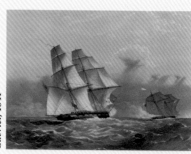

British expedition goes up the Niger River as far as the Benue, to stamp out slavery. The expedition, commanded by Capt. Allan, purchases a strip of land at Lokoja, at the confluence of the Niger and the Benue rivers, on which the town of Lokoja was later built.

1842

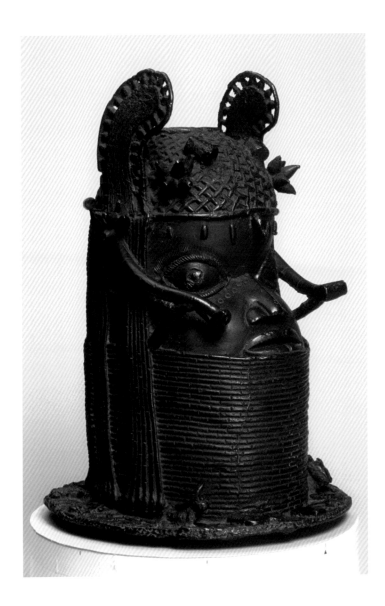

— *Left*

Commemorative head. Copper alloy, made for an altar dedicated to an Oba or King of Benin. Early 19th century.
Royal Albert Memorial Museum & Art Gallery, Exeter

1843
Captain Joseph Denman puts together the Instructions for the Guidance of HM Naval Officers Employed in the Suppression of the Slave Trade

Revd. Henry Townsend arrives in Abeokuta, Nigeria, with christian Yoruba people returning from Sierra Leone.

1844

1845
An Act is passed which allows Spanish or Portuguese ships to be searched north or south of the Equator.

1846

1847

1848
Slavery abolished in French colonies

1849

Staff and decorated gourd
container, South-west Nigeria.
Before 1852.
Royal Albert Memorial
Museum & Art Gallery, Exeter.
Photographed at Plymouth City
Museum and Art Gallery, 2007

RAMM's aims and objectives. It proved to be a fine example of teamwork throughout the region, which was in part reflected by the effective sharing of resources. This project also became a major exercise in public consultation and this significant undertaking was pivotal to the processes behind the creation of an exhibition and its associated activities, such as seminars and educational publications.

Exeter's collection

RAMM's ethnography collection was recognised by the MLA in 1998 as being of national importance. It consists of almost 13,000 items and is one of the most important collections outside of London. There is a good representation of high quality material from almost every part of the globe and they typically have their origins in 19th century colonialism. Donations, bequests and purchases were made from individuals working as colonial administrators, traders and soldiers. Collections were also acquired from local institutions, for example, the Devon and Exeter Institution which was founded in 1813. This institution was set up as a centre of learning which eventually transferred its natural history and ethnographic collections to the new Albert Memorial Museum in 1868. The collection continues to grow, its strengths include material from West Africa and the Pacific.

Objects selected for the exhibition

For the historical element, Human Cargo brought together key items from regional museum collections, like Torquay, Bristol, Plymouth and Exeter ensuring the exhibition could present powerful narratives on consumerism, historical colonialism and contemporary slavery. Exeter's permanent ethnography gallery, of some 900 items, includes an honest interpretation about its colonial roots, questionable ethics pertaining to acquisition and the unequal relationship that commonly exists between a colonial government and its subjects.

A careful selection of objects included material that in the main required little conservation work as these pieces were already on display.

1850
Slave trading abolished by
Brazil

1851
Lagos is annnexed by Britain,
in order to simplify control of
slave trafficking.

1852
Royal Navy patrols operate out
of Lagos, including Lt Bent on
the Vengeance.

1853

1854

1855

1856

1857

1858

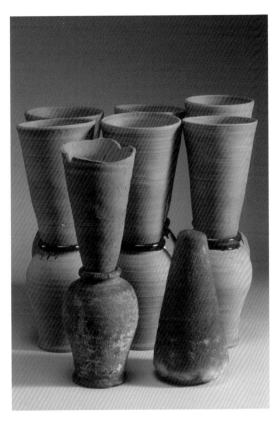

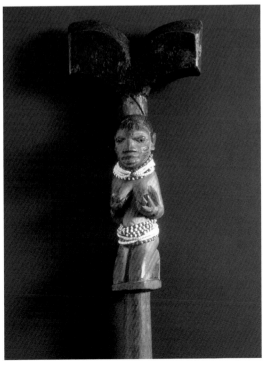

— *Above*

Sugar moulds. Earthenware, used in refining sugar in Exeter, with a sugar cone. 17th century and modern. Royal Albert Memorial Museum & Art Gallery, Exeter

— *Below*

Staff. Wood decorated with glass beads used by followers of Shango, the Yoruba god of thunder, South-west Nigeria. Before 1852. Royal Albert Memorial Museum & Art Gallery, Exeter

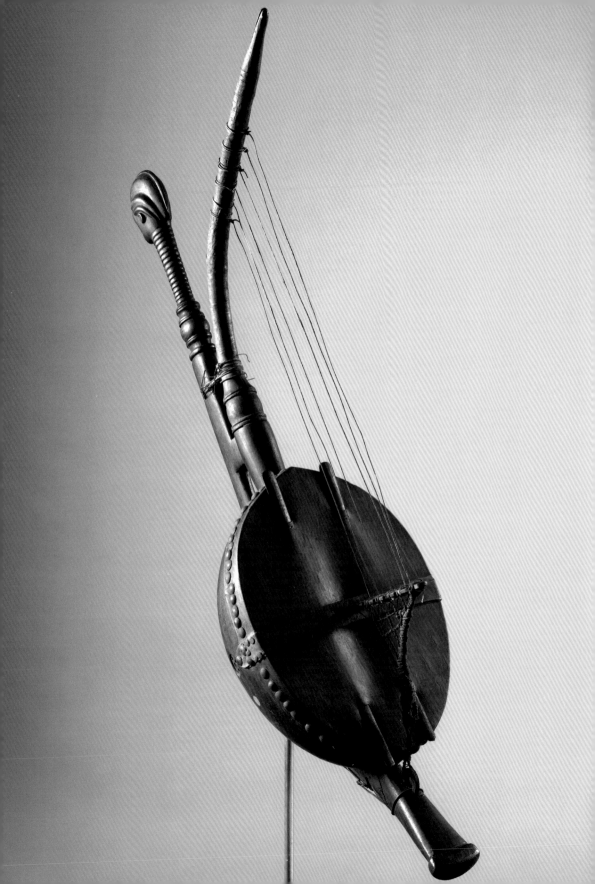

There were, however, one or two exceptions; one is an elegant-looking musical instrument, a banjon[2], that bears a striking resemblance to the harp-lutes made by the Mende people of Sierra Leone. This was an ideal candidate for display. For many years it had been kept boxed within the store because it was badly fragmented. Careful conservation work was required to bring this item into an acceptable condition and this is just one example of how useful the DCF grant has been in making items normally kept in store more accessible.[3]

This beautiful instrument carries a very interesting tale and one that hasn't yet been told. It was acquired not from West Africa, but from the South American port town of Cartagena in Colombia and was possibly made in the 18th century. Enslaved Africans being transported to plantations could not bring any possessions with them and so it is possible that this banjon may have been made by someone who had been transported there. Its provenance remains a mystery. There is little in the way of documentation to inform on how it had been obtained or the method by which the donor, James Annger, had acquired it. The instrument's maker, typically remains unknown despite the banjon showing an apparent link to Mende culture. Its story, what little is known of it, sadly reflects how enslavement equates to a significant loss of identity.

Many of the historical items in Human Cargo convey the complex relationship between the object donor and the people they encountered in a colonial Africa. Exeter-born, the Reverend Henry Townsend, is one example. He was a man charged with spiritual work at an early age; he wanted to devote his life to foreign missionary work. Once accepted by the Church Missionary Society, Townsend spent his first few years as a volunteer in Sierra Leone having arrived in 1836. It was there that Townsend first caught sight of the multitude of freed slaves in Freetown.

In Sierra Leone, as is generally known, a large number of liberated Africans are gathered together, persons representing a great number of the Native tribes of West and Central Africa. These were brought there in slave ships –

— Opposite Page

Banjon (harp-lute), collected in Cartagena, Colombia, donated to Royal Albert Memorial Museum & Art Gallery, Exeter, in 1870.

1859

1860
Britain begins recruitment of indentured labourers from India and China to work in gold mines in South Africa.

Abraham Lincoln elected President of USA: slave trade to American sea-board is stopped.

1861
Lagos comes under British rule, as the Lagos Colony.

1862

1863

1864
Samuel Ajaye Crowther becomes the first African Bishop, of the Dioceses of the Niger. He had been rescued from a slaver in 1822 and educated by the Church Missionary Society.

1865
United States of America abolishes slavery.

caught in the act of transporting them to some port on the western side of the Atlantic Ocean – and set at liberty.[4]

As part of their liberation they were converted to Christianity and taught reading and writing and certain craft skills, sufficient for people to build their own homes. Whilst never directly stated in his memoir, it is very likely that Townsend was immersed in his duty to enlighten '[The] many who then were in heathen darkness.'[5]

Numbers are never given in his memoirs but the impression left on the reader is that there were a considerable number of people waiting to return home. Townsend then travelled to Yorubaland on the schooner Wilberforce with 59 of those freed. His arrival in Abeokuta in 1843, ironically found favour with the inhabitants, particularly with a Yoruba leader named Shodeki.

I was introduced to Shodeki's brother to be chiefs of the camp; they all expressed their desire, and seemed indeed glad of the idea, that Missionaries should be sent among them. The return of their people from Sierra Leone has excited their highest admiration of the English.[6]

Figure of Eshu, the Yoruba trickster deity, carved wood. Before 1868. Royal Albert Memorial Museum & Art Gallery, Exeter.

This rare wooden figure depicts Eshu, a powerful orisha, or lesser deity, in the Yoruba pantheon. It was donated by Townsend in 1868 and originally it would have been placed with an identical figure on either side of the entrance to the Palace of Chief Ogunbona of Abeokuta. Eshu is the only orisha to be depicted iconographically. This carving depicts him kneeling, holding a staff in the form of a flute whilst wearing a hairstyle worn by women. He conveys both female and male attributes and this reflects his ability to cross human boundaries and those of the physical and the spiritual world. Furthermore, and this could be seen as having significance as a gift from Chief Ogunbona to Townsend, Eshu is associated with the act of mediation.

Eshu acts as the divine messenger and frequently mediates between humans and the forces of the spiritual world. If appropriately honoured,

1866

1867
The West Coast of Africa Squadron is withdrawn. About 1600 slave ships were captured and nearly 150,000 Africans liberated between 1807 and 1860.

1868

1869

1870

1871

1872

1873

1874
British army Ashanti expedition sacks Kumasi.

he brings fortune; however, fortune is taken away from those if his authority is not recognised.[7] As the guardian of secret knowledge he also plays the role of the trickster god, confusing and causing those people who anger him to lose their way.[8] Eshu is indeed a powerful figure.

This carving is marked with the word idol, which suggests that it was given to Townsend as a result of conversion by the ruler of Abeokuta. It was probably interpreted as a devil by Christian converts.[9] The giving of this figure could have acted, in itself, as a means of peaceful mediation, transforming an individual's belief in an established faith for a new one. In the hostile environment the Yoruba in Abeokuta were experiencing, this new faith was believed to offer hope and positive change.

The material displayed within this exhibition informs more about the roles of the donors who acquired them than the people who made them. The copper alloy commemorative head that represents British involvement in Benin was donated by Ralph Locke, one of the two survivors of the ill-fated trading mission in January 1897 and a participant in the renowned punitive expedition one month later. Within that same case we also have a large and heavy flintlock blunderbuss that Locke had appropriated from a canoe that was operating in a River Niger estuary at the time of the expedition.

One other item worthy of mention can be found in the ethnography collection at the Plymouth City Museum & Art Gallery. This takes the form of a large colourful umbrella from Abuja, Nigeria and was displayed in the centre of the exhibition's historically-focused Watercolour Gallery. It was originally made in Nigeria from European damask and is European in appearance. Originally it would have formed part of a great procession offering shelter to its owner, probably on horseback surrounded by attendants and followers. The umbrella became a symbol of status for the Sirikin, or chief, who owned it, as too was the horse he rode.

The umbrella was acquired in the 19th century by Lieutenant Pye an officer with the West African Frontier Force. Pye had been informed by the local people that the umbrella carried an approximate value of six slaves. This information is actually marked on the umbrella and highlights

1875

1876
King Leopold II of Belgium convenes a conference of European powers to discuss how to abolish the Arab slave trade in Africa. However, this is a ruse to justify establishing his own territory in central Africa.

1877

1878

1879
United Africa Company starts trading in the Niger River.

1880

1881

1882

— Opposite Page

Processional umbrella from
Abuja, Nigeria, covering of silk
damask. Before 1902. Plymouth
City Museum and Art Gallery.

the fact that the umbrella existed as a commodity with a human price that
was once deemed acceptable.

It is a powerful object that infers much about colonialism in Africa,
the control of nations and their natural resources. Colonialism equates
to making profit out of exploitation. The Human Cargo exhibition did not
require a display of slave chains to open a discourse on the act of slavery.
Instead it made this visible through a variety of striking objects that were
accompanied by strong human stories; objects that have become the
voices for many of those lost in the tragedy of the transatlantic slave
trade.

References

[1] Since 1998, the ethnography collection was promoted through an experimental website called MOLLI, the Museum OnLine Learning Initiative, in partnership with the University of Exeter. This was transformed in 2009 to World Cultures Online www.rammworldculturesonline.org.uk. This change means that the website can clearly be indentified with the Museum but it also means that new content can be added quickly with a user-friendly technology.

[2] From correspondence with Dr. William Hart, University of Ulster, pers comm 28/08/09.

[3] Since the conservation work on this item was completed in 2007, it should be noted that this instrument has appeared in another temporary exhibition called *Beauty – In the Eye of the Beholder?* at the Museum in the Park, Stroud in 2008. From the end of 2011, it will be on permanent display in the World Cultures gallery.

[4] Townsend, George 1887. *Memoir of the Rev. Henry Townsend: Late C.M.S. Missionary, Abeokuta, West Africa* Exeter: James Townsend p.13

[5] Townsend, George 1887. *Memoir of the Rev. Henry Townsend: Late C.M.S. Missionary, Abeokuta, West Africa* Exeter: James Townsend p.31

[6] Townsend, George 1887. Memoir of the Rev. Henry Townsend: Late C.M.S. Missionary, Abeokuta, West Africa Exeter: James Townsend p.28

[7] Drewal, H. J., Pemberton III, J. & Abiodun, R. 1989 The Yoruba World in Wardwell (ed.) *Yoruba: Nine Centuries of African Art and Thought* New York: Harry N. Abrams Inc. p.29

[8] Pemberton 3rd, J. 1982. Descriptive catalogue in Holcombe (ed.) *Yoruba Sculpture of West Africa* London: William Collins Sons & Co. Ltd p92

[9] Pole, L. 1999. *Iwa L'Ewa: Yoruba & Benin collections in the Royal Albert Memorial Museum Exeter,* Exeter: Exeter City Museums p.13

1883

1884-1885
The Berlin conference
establishes right of all European
nations to trade in the Niger,
among other rights.

1885
Leopold establishes the Congo
Free State, with himself as sole
ruler. He frees thousands of
Africans from their Swahili
Arab masters, in order to use
them himself as slave labour.

*Cartoon of King Leopold II
of Belgium*

1886
Cuba abolishes slavery

The Royal Niger Company is
formed. It assumes trading
rights over a vast area of what
is Northern Nigeria. It levies
customs duties, imposes fines,
and operates courts. It creates a
constabulary.

1887

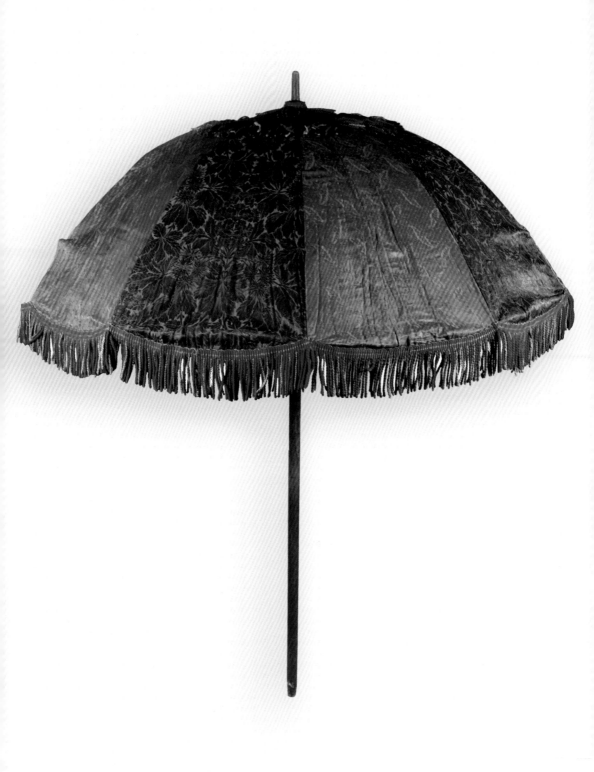

The Slave Trade and Socio-Cultural Transformations in the Northern Volta Region of Ghana

Kodzo Gavua

Introduction

Until the early 20th century the geo-political area which transformed into modern Ghana was a major source of enslaved people, who were traded in domestic and external markets. Several forts and castles built by European agencies that engaged in the trade to serve as residences, warehouses, and trading centres are found along the coastline of this area (Anquandah 1999; Doortmont and Savoldi 2000; van Dantzig 1980). The history of chiefdoms and families whose forebears actively enslaved and traded people, and various routes along which slave-trading activities were undertaken in the area, have been studied and documented (e.g. Anquandah 2007; Perbi 2004; Wilks 1975). Oral historical accounts, folklore, history lessons, and programmes organized by public, private and international agencies are other channels which inform about this sordid history. Nonetheless, public knowledge and understanding in Ghana of the processes of the enslavement and trade of people, and the impact these processes have had on society and culture in the country remain very limited.

This text discusses some significant transformations that occurred in the society and culture of the people of the northern Volta Region of Ghana largely as a result of slavery, the trade in enslaved people, the efforts of the British government to prohibit these activities through the 1807 and 1833 Acts of the Parliament of the United Kingdom, as well as the proclamation of the existence of the Gold Coast Colony on July 24, 1874. It focuses on an area of Northern Eweland (Gavua, 2000; Agbodeka, 1997), on the eastern corridor of the Volta, through which a major route linked market centres of northern Ghana, including Salaga, to southern markets and ports such as Akuse, Ada, Keta and Ningo.

— Opposite Page

Map of Ghana in 2007 showing the study area

1888 Brazil abolishes slavery

1889

1890 George Washington Williams, a black paster working in the Congo, accuses Leopold of engaging in slave-dealing. He writes an open letter to Leopold, distributing it in Europe and the USA.

1891

1892

1893

1894

1895

1896 British expedition led by Maj. Baden-Powell, occupies Kumasi.

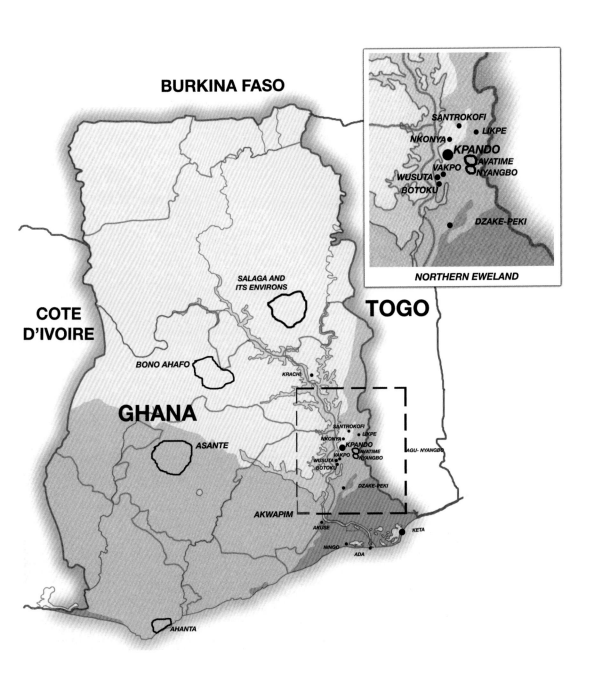

What is referred to here as social and cultural transformation comprises alterations that occurred in the fabric and dynamics of the society and culture of the people of the area. These alterations may be influenced by a complex of internal and external factors, including physical environmental changes. For the sake of this presentation, however, emphases are placed on alterations effected by the enslavement and trade of people stimulated particularly by the abolition of the trade by the British. Brief outlines of the social and cultural contexts of life in the area before and after 1807 are followed by a discussion of how slavery, the trade in enslaved people, and the passing of Acts of the Parliament of the United Kingdom influenced the following in the area:

- Composition of the local population and settlement patterns.
- Social structure and social organization.
- Local dialects.
- Interactions between the local Ewe people and the Akan.
- Interactions among the local communities.
- The creation of an internal African Diaspora.

There is paucity of documented information on the pre-colonial life-ways of the people of the area, as relevant research has been very limited. This discussion is, nonetheless, informed by ethnographic, linguistic, oral and written historical as well as archaeological data I have obtained, to date, as part of a study of globalization and culture change in the Volta Region of Ghana.

The Pre-1807 Social and Cultural Context
Archaeological, oral and written historical accounts suggest that by the 17th century, most of the diverse groups of people found in the area and its neighbourhood had immigrated from different directions and were well settled (Gavua, 2000). Among these groups are the Ewe, who constitute the dominant language group and who claim to have immigrated from the east of their present homeland, the Avatime, originally from Ahanta in

1897
In January, a force of 500 Royal Niger Company constabulary, leaves Lokoja, on the Niger, to attack Bida, on the pretext of punishing Etsu Nupe, the king of Bida, for slave raiding. The force is commanded by Sir George Taubman Goldie.

British Government mounts a Punitive Expedition to invade the City of Benin in reprisal for the death of British personnel on a trading mission. Ralph Locke was one of the survivors.

1898
The force was named the West African Frontier Force, under the command of Col Lugard.

1899

western Ghana, the Santrokofi and Likpe from the region north of Asante, the Nkonya from the Akwapim mountain region, and the Nyangbo from Agu-Nyangbo in the Republic of Togo. Although minor skirmishes among these groups and their various communities over land, wild-life, women, and murder were not uncommon, major wars in the area seem to have begun in the second half of the 18th century with the rise and expansion of Akwamu and Asante influence.

It appears from the settlement patterns, settlement histories, and the heterogeneity of the groups that the area and the territory to which it belongs had provided a relatively safe haven for peoples, who were seeking refuge, from war, slave-trading activities and other forms of coercion and repression (Gavua, 2005) when slavery and slave trading activities were intensified, particularly in the 19th century. Early direct European interaction and influence in the territory commenced only in 1847, almost four hundred years following the beginning of European interventions on the Guinea Coast at Elmina. The territory became part of the German colony of Togo in 1884. Prior to this period it had no central authority. Each of its several communities was (and remain) autonomous and was administered primarily by indigenous authorities, including priests, custodians of land, chiefs, and councils of elders (Gavua, 2000). It became a British Protectorate only after the First World War.

The Post-1807 Abolition Context

The 1807 and 1833 Acts of the Parliament of the United Kingdom, which prohibited British involvement in the enslavement and trade of people, did not apply to the area of my concern until after the First World War, when German colonial administration of the area was halted. Thus between 1807 and 1893, when an order on 'freeing persons held as slaves' was issued by von Puttmaker, governor of the German colony, there was a boost in the enslavement and trade of people in the area. Attempts by the British and their indigenous African allies to enforce the law prohibiting slavery and the trade in British controlled territories might have influenced dealers, who were unable to operate freely in those territories, to find

— Following Page

A section of the Vakpo rock-shelter complex, 2007

1900
The British Government takes over the functions of the Royal Niger Company on 1st January. The RNC reverts to being a trading company. Col. Michael Broun collects items confiscated by members of the Company in the Yoruba area.

1901
Edmund Morel, a shipping clerk, realises how labourers were being treated in the Congo. He starts writing newpaper articles about the Congo situation. The cause is also taken up by Roger Casement, the British Consul in the Congo.

1902
Lugard forms an expedition to deal with French incursions in the north-East frontier on Northern Nigeria. It sets out in February for Bauchi. The expedition invades Bauchi and deposes the Emir as a punishment for slave-dealing. Another expedition attacks Abuja in June, as reprisal for killing a native missionary. Lt Pye is a member of this force.

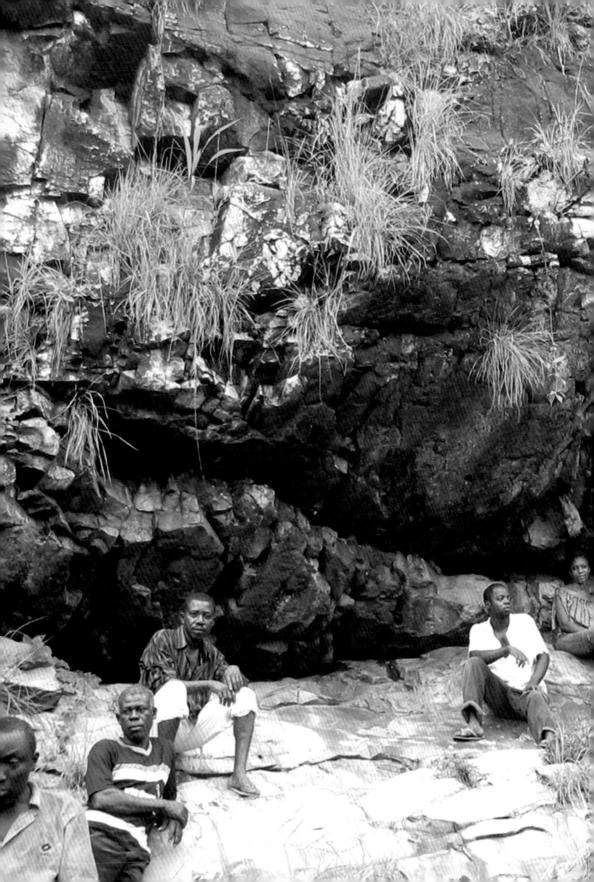

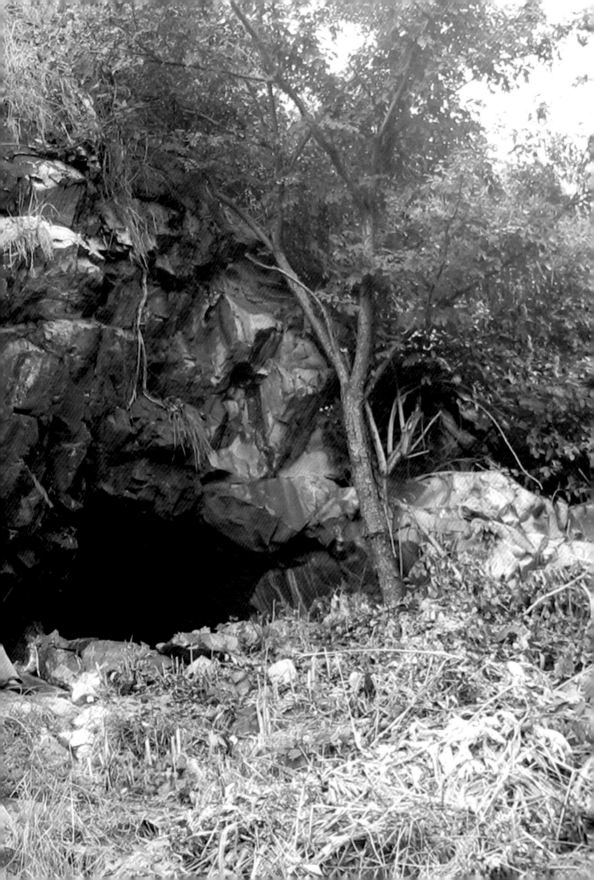

alternative markets and routes to the coast, including those of the area (see Johnson, 1986: 356). Also, German missionaries operating in the area, as well as German colonial authorities, failed to intervene against the trade in any meaningful way (Ustorf, 2002). There are reports of the connivance of the German colonial administration in the trade (Neue Preussische Zeitung, 1892). Another contributing factor was that tariffs on gunpowder and spirits, which were the main currency of trade at the time, were lower in the area than in the British controlled territories (Ustorf, 2002).

Safe from European abolitionist activities, therefore, the area provided a relatively free market for slave-trading and related activities by internal and external agencies. Some traffickers in human beings from Salaga and adjoining areas, unable to easily transfer their human cargo through British controlled territories to coastal ports, preferred to offload their cargo onto markets at commercial centres such as Kpando (Ustorf, 2002). By 1893, children between the ages of seven and twelve became the main commodities (Johnson, 1986).

There was probably a glut in the local market, which enabled relatively affluent local people to buy, enslave and keep as many people as possible to boost family labour. According to both written and oral accounts, enslaved females were bought and taken into marriage by men who were unable to find wives, or who desired several wives, and it was fashionable for a well-to-do man to display 'his wealth not only in the number of wives but also in the number of his slaves' (Johnson, 1986). While the German colonial administration occasionally handed over children of freed slaves to the North German mission particularly after 1894, some slaves, who absconded from their owners, were recruited, for example, from Kpando by the British to join the Hausa Constabulary that served British colonial interests (Johnson, 1986: 355).

The slave-trading market attracted the Akwamu, who wielded much power and influence in the area and exacted human cargo from local chiefs, until their defeat in 1833 by a combined armed force of the local communities (Amenumey, 1986). From 1866 to 1869 the Asante,

1903
Capt Pye gives collection of items from Northern Nigeria to Plymouth Museum. These items include material acquired while on the expeditions to Bauchi and Abuja.

Cotton robe taken by Lt Pye, West African Frontier Force, 1902

Casement puts together a report on the state of the Congo. It documents a country run on slavery.

1904
British Government publishes Casement's report.

Casement and Morel form the Congo Reform Association to campaign against Leopold's control of the "Congo Free State".

invited by the Akwamu in a bid to regain their hold on the area, its trade routes and slave dealing markets, invaded and fought the local people (Amenumey, 1986; Wilks, 1975). In spite of any links that might have existed between these intruders and some of the local communities before the fighting, interaction between the Asante and the communities, such as Wusuta, where the Asante army pitched camp and used as military bases was intensified during the period of the war. The interaction led to the establishment of bonds and links between the Asante and the local people and to the capture, kidnapping and relocation by the Asante and their allies of many local peoples.

Physical evidence of slavery and the trade

The physical evidence of slavery and the trade in enslaved people researched in the area by the author can at best be circumstantial at the moment as a lot more study is required to validate them. Among this evidence is a rock-shelter/cave complex at Vakpo, a shrine and a 'slave market' at Wusuta, and an ancient shrine at Dzake-Peki.

A history of the cave and rock-shelter complex at Vakpo, compiled by the Vakpo Area Traditional Council, hints that the complex served as a refuge where children, women and royal paraphernalia were hidden away during times of war and from slave raiders. Other accounts obtained from local informants suggest that before the complex became a refuge, it had been a resort and warehouse where traders, who travelled southwards from northern Ghana with human cargo, took rest and kept their cargo. The three caves in the complex could collectively accommodate at least 150 people at a time.

The Wusuta shrine, seen by the author in his childhood, was located along the Volta River and has been inundated by floodwaters of the Volta following the construction of the Akosombo dam. Known as Mianorfe (our mother's home), this shrine was, according to local accounts, a major centre where enslaved people brought there from across the Volta were fed and treated for various ailments before they were transferred elsewhere for sale. Excavations conducted by the author at a site at

1905
Francis Pinkett is active in the Yoruba area of Nigeria as an officer of the Lagos Protectorate.

1906

1907
Britain cease to recruit indentured Chinese labour to work in South Africa

1908
The "Congo Free State" was bought for about 200 million francs. 50 million francs was paid to Leopold in compensation. Belgium assumed control but the slave labour system did not end.

1909
Congo Reform Association (CRA) holds meetings to continue its campaign. 3000 people attend a CRA meeting in Plymouth.

1910-20
Dr. John Stephens is active in collecting items from the Yoruba area of south-west Nigeria.

Site of Dente Shrine,
Dzake-Peki, 2007

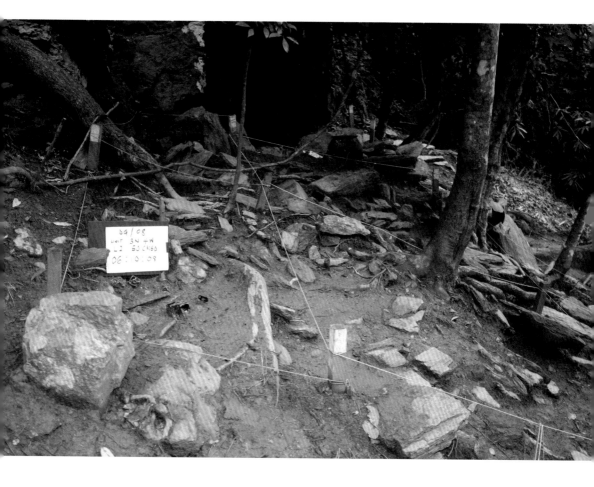

1911 1912 1913 1914 1915 1916 1917 1918 1919 1920 1921

Altar at the Dente Shrine,
Dzake-Peki, 2007

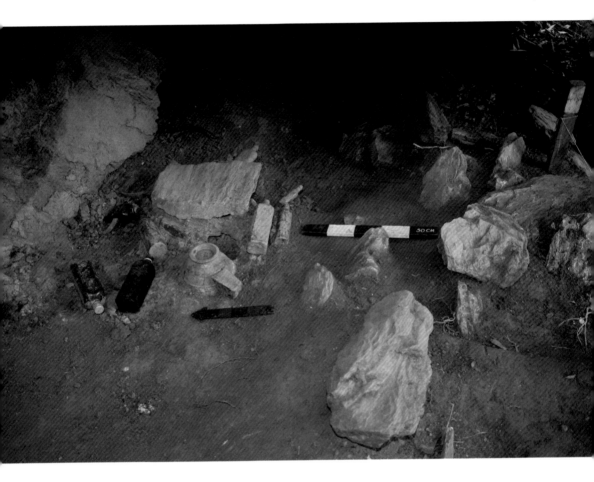

1922
Haiti completes reparation
payments to France: 150
million Francs – This represent
70% of Hiati's gross national
product.

1923

1924
League of Nations sets up
the Temporary Slavery
Commission. The Commission
reviews the situation of slavery
in all its forms around the
world.

1925

1926
Slavery Convention 1926 is
published by the League of
Nations. This Convention calls
for the abolition of slavery in all
its forms.

1927

1928

1929

Wusuta, which older citizens of the town call Adosime (Ado's market) and identify as having been a major slave market until the early 20th century, yielded pottery and beads that predate the 20th century.

A rock-shelter site at Dzake-Peki has also been associated by citizens of Peki with the trade in enslaved people. Informants claim this site, which they refer to as Dente-ga (Dente's hill), was a shrine of Dente, a legendary deity of Krachi, a town that is about 300 kilometers to the north. The site is reported to have been the final stopover, where enslaved people, who were being led towards the coast from the northern frontiers of Peki were 'cleansed', 'purified', prayed for, and treated of various ailments before they were acquired by Akwamu and other merchants. Excavations I undertook at the site in 2007 yielded hordes of 19th century gin and schnapps bottles, cowry shells, features of stone that appear to have been an altar and a few sherds of European ceramics. The volume of bottles recovered suggests the site had been actively used prior to its abandonment. Also associated with the shrine are two fairly large metal chains, which I collected from the custodians of the shrine and deposited, with their kind permission, at the Ghana National Museum in 2000. Although the origin of the chains is unknown their ownership has been claimed by the custodians.

Consequences of slavery and Slave Trade-related activities

It would be unfair to attribute all challenges that confront the indigenous peoples of the area to the slavery and the Slave Trade. Nevertheless, the current economic conditions, composition and settlement behaviour, social structure and organization, dialects, inter-group relations and migration patterns of the people have been significantly impacted upon.

Poor economic conditions

The greatest consequence of slavery, the trade in enslaved people and their abolition on the people of the northern Volta Region, has been economic deprivation. Local beneficiaries of the trade would have amassed wealth. However, major disruptions of the relative peace in

1930
The International Labour Organisation publishes the Forced Labour Convention. The Convention sets limits on the use of forced or compulsory labour. It is concerned about forced labour in many countries, including the USA, South Africa and India.

1931

1932

1933

1934

1935

1936

1937

1938

1939

1940

which the people of the area had been pursuing economic activities, including the production, forging and distribution of iron and boat-building, were caused by activities and events associated with the post abolition era. This resulted in low productivity and limited supply of local products and the rise in demand for relatively cheap mass-produced European commodities. To date, the local economy has not recovered and the people remain poor. Other repercussions of the trade and its abolition are discussed below.

Alterations in the composition and settlement behaviour of communities

Intermarriages between the local Ewe people and enslaved men and women, who freed themselves and whose freedom was bought, engendered major changes in the fabric of individual communities. Hitherto homogeneous communities became heterogeneous single units that comprise people of Ewe, Akan, northern Ghanaian and other origins. This is reflected for example in variations in family names that are found in many of the communities in the area such as Gazali and Adu, which are of northern derivation, and Boateng, Obimpeh, Amankwa, Yeboah, Amponi, Osei, Tumfuor, and Dompreh, which are Akan.

The influx of enslaved people of northern Ghanaian origin during the post-abolition period has also led to the creation of 'strangers' quarters' (zongo) in some of the communities in which there were major markets such as Wusuta and Kpando. The long established interactions between the peoples has now fostered peaceful coexistence, understanding and harmony between the local Ewe speaking people and their northern neighbours, although each of the groups is mindful of its identity.

Alterations in social structure and social organization

The most noticeable alterations in the structure and organization of the society of the Ewe speaking people of the northern Volta Region were influenced by interactions between the culture of the invading Akwamu and the Asante, particularly after 1807. Kinship and indigenous leadership

positions and their functions were, for example, altered. Atypical of the Ewe, who are patrilineal and patrilocal, many of the local communities have no strict rules about inheritance and residency. People are free to inherit from their fathers and their mothers. In many cases, men even reside in the homes of their wives, while children live with their mothers.

Most towns and villages that were hitherto administered by chief custodians of land (Afetorfia in Ewe), in conjunction with chief priests of important deities (Trorfia in Ewe) have since the 19th century adopted the Akan system of chieftaincy, which is based on the initiation of a 'black stool' and is fraught with all kinds of litigation. The local people conveniently created positions of various divisional and sub-divisional chiefs for mainly military purposes. Technically, each divisional chief was a leader or commander of a given military wing (kpekpe in Ewe). Thus stool names of chiefs as well as terms, chants and songs that are related to chieftaincy are mainly in Twi. Some chiefs have Twi names such as Ansa Kwao, Osei Tutu Brempong, Yeboah Koni, Yao Barimah, and Adom, although they are all Ewe.

Alteration of local dialects
Another effect of interactions caused by the trade on the Ewe communities is the fusion of Ewe words and expressions with Akan ones. The fusion and incorporation pertain, for example, to language, whereby many Twi words and expressions are found in the dialects of the people (Ansre, 2000).

Mistrust and suspicion between the local Ewe people and the Akan
The nature of the interactions between the Akan and the Ewe of the northern Volta Region engendered negative perceptions and stereotypes between the two groups. These perceptions and stereotypes are transferred, unfortunately, from one generation to another. Similarly, the assistance provided by southern Ewe warriors to the Asante in the slave trade and the wars of slavery also created mistrust between the people of the area and the Anlo, although they are all Ewe. This mistrust has been

1953

1954

1955

1956
UN publishes the Supplementary Convention on the Abolition of Slavery. This Convention seeks to criminalise and abolish debt bondage, serfdom, forced marriage, child exploitation and all other slavery-like practices.

1957

1958

1959

1960

1961

1962
Saudi Arabia abolishes slavery

minimized in recent times, however, following cordial, cooperative and friendly interactions as well as intermarriages between Anlo and Tongu fishermen and farmers and the people of the northern Volta Region, who live along the Volta Lake.

The creation of an internal 'Diaspora'

The trade in enslaved people, the quest for control of trade routes and markets, and related wars resulted in the emergence of an internal 'Diaspora' of various groups of Africans in Ghana (Gavua, 2008). First, several peoples of northern West African extraction, whose forebears were relocated to the northern Volta Region as a result of the trade have now become an integral part of the society of Northern Eweland. Similarly, several people from towns of the northern Volta Region, particularly, Wusuta, Peki, Botoku and Aveme were lured in various ways into slavery in Asante territory in 1869 by Asante warriors (Gavua, 1980; Wilks, 1975). While some of these people were probably sold eventually to European merchants, others were relocated to various Asante, Bono and Kwahu towns such as Nsuta, Juaso, Obogu, Atebubu, Abesim, Nkwatia, Obo and Abetifi. As part of a study of the 'Internal African Diaspora', I visited a number of these towns, located and met with members of families that claim descent to Wusuta, Peki and Botoku (Gavua, 2008).

Although most of the Ewe in the internal Ghanaian Diaspora have been integrated into Akan and other societies, they are conscious of their origin, partly because they are aware of their history and also because they are constantly discriminated against where they are. A few of them visit Wusuta on pilgrimage, while some visit to trace and reconnect to their families. Recently, a group of people from Gbese in Accra, who claimed their great grandmother was kidnapped from Wusuta in 1825, was assisted by the author to trace their family roots in Wusuta successfully.

There may be some reservation about the use of the term Diaspora in the case of the Ewe who have been relocated to Asante and elsewhere in

the Akan world (Posnansky, 2009: 294) on grounds that orthodox usage of the term refers to 'longer-range' movements of people relocation of people such as those of the Jews and Africans to the America, the Gypsies across Europe. Be that as it may, the involuntary relocation of people from their original homelands to elsewhere, whether over short or long distances, has the same impact on the affected people. Thus, a Diaspora can be created irrespective of distance and time.

Conclusion

I have presented information to show that slavery and the enslavement of human beings were not stopped or minimized in the northern Volta Region with the passing of the Acts of the Parliament of the United Kingdom that abolished those wayward activities. The activities were rather boosted and intensified in ways that curtailed the peace and freedom of the people until the early 20th century. The events fomented major transformations in the life-ways of the people, and engendered inter- and intra-group discords, which various interest groups now exploit to advance their lot. Nonetheless, the people have remained resilient and continue to rebuild their lives in strides.

It should be clear from the discussion that like the people of the northern Volta Region of Ghana, there are many people in Ghana and across Africa, who have been relocated away from their homelands as a result of slavery, the trade in enslaved people and the efforts that abolished these practices. There is, hence, an internal African Diaspora of victims of the pre- and post-abolition trade in people, including the descendants of house slaves, freed slaves, enslaved people, whose freedom was bought, and those who escaped from their owners. Many of these people have endured conditions that are similar to those encountered by Africans in the American and European Diaspora. Some of them have been well integrated into their 'new' communities and have risen to various positions of power, but others continue to be discriminated against by the members of their host communities.

I expect the information in this paper to deepen understanding among

Ghanaians and other Africans in the Diaspora of their common heritage, and goad them on to minimize intra- and inter- group discord. The experiences in the Northern Volta Region and elsewhere must inform us, Africans, wherever we find ourselves, to understand and recognize our common heritage and cultural unity. We must begin to live over and above so-called tribal and ethnic differences, and must not only revel in thought of our resilience, but harness our cultural unity and heritage to transform our conditions of life so as to not remain beggars and consumers but producers and equal partners in the global market place. For, we may be separated by distance and language, but the blood and spirit in us remain the same.

1992

1993

1994

1995

1996

1997

1998

1999
The International Labour organisation (ILO) publishes the Convention on the Worst Forms of Child Labour.

This Convention requires governments to eliminate all forms of slavery, especially forced recruitment of children for use in armed conflict.

2000
UN publishes the Protcol to prevent, Suppress and Punish Trafficking in Persons, especially Women and Children. This Protocol requires governments to pass legislation prohibitng and punishing trafficking for sexual and labour exploitation.

References

Agbodeka, F. 1997. A Handbook of Eweland, Vol. I: The Ewes of Southeastern Ghana. Accra: Woeli Publishing Services

Amenumey, D. 1986. The Ewe in Pre-Colonial Times. Accra: Sedco Publishing

Anquandah, J. 1999. Castles and Forts of Ghana. Paris: Atalante

Ibid. (ed.) 2007. The Transatlantic Slave Trade: Landmarks, Legacies, Expectations. Accra; Sub-Saharan Publishers

Ansre, G. 2000. The Ewe Language. In Gavua, K. (ed.), A Handbook of Eweland, Vol II: The Northern Ewes in Ghana. Accra: Woeli Publishing Services, pp. 22-47

Doortmont, M.R. and Savoldi, B. (eds.) 2000. The Castles of Ghana, Axim, Butre, Anomabu: Historical and architectural research project on the use and conservation status of three Ghanaian forts. Associazione Giovanni Secco Suardo Culture Lab

Gavua, K. 1980. A Survey of the Prehistory of Wusuta. Unpublished B.A. Long Essay, Department of Archaeology, University of Gnana, Legon

Ibid. 2000. A Handbook of Eweland, Vol II: The Northern Ewes in Ghana. Accra: Woeli Publishing Services

Ibid. 2005. Oppression and the Struggle for Freedom in the Northern Volta Region of Ghana. In Agorsah, E.K and Childs, G.T. (eds.) Africa and the African Diaspora: Cultural Adaptations and Resistance. Pp 138-141. Bloomington: Authorhouse

Ibid. 2008. Researching the Internal African Diaspora in Ghana. In Insoll, T. (ed.), Current Archaeological Research in Ghana. BAR International Series 1847, 2008. Oxford: Archaeopress

Johnson, M. 1986. 'The Slaves of Salaga'. The Journal of African History 27.2 (1986): 341–362

Manoukian, M. 1952. The Ewe People of Togoland and the Gold Coast'. Ethnographic Survey of Africa, West Africa, Part 1A. No. 1.

Perbi, A. 2004. A History of Indigenous Slavery in Ghana: From the 15th to the 19th Century. Accra: Sedco publishing

2001

2002

2003
President Aristide of Haiti demands return of reparation payments from France: US$ 150million.

2004
President Aristide toppled from power in Haiti in a bloody rebellion, plus pressure from the USA and France. The replacement regime rescinds the reparation repayment demand.

2005
ILO publishes a minimum estimate of the number of forced labourers in the world. In 2005, over 12,300,000 people are forced to work against their will under threat of punishment, in Europe, North America, Asia, and Africa. The main forms of forced labour are debt bondage, child labour, forced labour by the state, trafficking in people.

2006

Posnansky, M. 2009. Review of T. Insoll (ed.), Current Archaeological Research in Ghana.
BAR International Series 1847, 2008. Oxford: Archaeopress

Ustorf, W. 2002. Bremen Missionaries in Togo and Ghana: 1847-1900. Legon Theological Studies
Series. Accra: Asempa Publishers

Van Dantzig, A. 1980. Forts and Castles of Ghana. Accra: Sedco Publishing

Wilks, I. 1975. Asante in the 19th Century, the Structure and Evolution of Political Order. Cambridge: CUP

Neue Preussische Zeitung, 1892. Kreuzzeitung Berlin

2007
Britain commemorates 200th anniversary of the Abolition of the Slave Trade Act.

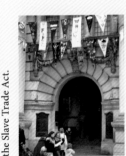

Sweatshop flags hung on the outside of Plymouth City Museum and Art Gallery to mark the closing day of the *Human Cargo* exhibition.

2008
25 March established by the United Nations as the first International Day of Rememberence of the Victims of Slavery and the Transatlantic Slave Trade.

2009

2010

2011
Slavery continues.

Exhibition Content List

Contemporary art commissions:

Jyll Bradley
Lent Lily
Edition of 32 rolls of screen print wallpaper, 2007.
Designed with Claire Turner and George Hadley.
Printed by Cole and Son, UK.
For Rosemarie Mallett.
Intervention in the Watercolour Gallery.

Lisa Cheung + WESSIELING
Sweatshop
Process project, mobile workstation sculpture, public event, 2007.
Facilitators: Joanne Gray, Charlotte Gunn, Donna Hanns, Jill Holland, Adam Milford, Helen Round.
Intervention in Gallery 3, on the Museum façade and "off-site" in the City.

Raimi Gbadamosi
Drake Circus
Museum trail, hand numbered edition of 2,000 leaflets: A2 folded to A5 two colour, 2007.
Leaflet written and designed by Raimi Gbadamosi.
Printed by Severnprint, UK.
Trail included items on display in the Explore Nature Gallery, Maritime Collection Gallery, Cottonian Collection Gallery, Museum shop and vestibule.

Theactre
Video, two screen work, 2007.
Filmed by, and edited with, Alia Syed.
Intervention in the North Gallery and Museum vestibule.

Selection of historical items from the reserve collections of Plymouth City Museum and Art Gallery for inclusion in the *Human Cargo* exhibition, 2007.
Intervention in the North Gallery.

Melanie Jackson
The Undesirables
Etchings, transcripts, animated sequences, sound, 2007.
Intervention in the Maritime Collection Gallery.

A Panorama of Branscombe Representing The Wrecking Of Panamax Container Vessel MSC Napoli And Of The Extraordinary Cargo And Splendid Excitement Of The News Media
Etching, 2007.
Intervention on the Balcony outside the Maritime Collection Gallery.

Fiona Kam Meadley
Free or Fair?
Process project, edition of 4,000 leaflets: A2 folded to 210 x 120 mm full colour, competition, public event, 2007.
Leaflet research, text and drawings by Fiona Kam Meadley.
Contributors: William Elford (Plymouth Committee for the Abolition of the Slave Trade 1807), Harriet Lamb (Fairtrade Foundation), Dudley Tolkien (Plymouth Global Justice Group), Sally Rogerson (Plymouth Quaker Meeting House), Linda Gilroy (MP for Plymouth Sutton).
Designed with Chris J. Bailey.
Printed by Severnprint, UK.
Intervention in the North Gallery, Museum vestibule, and "off-site" in the City.

Historical materials:

Trade in Humans Across the Atlantic

Iron bar
Copy of the type of iron bar exported in large numbers from Europe to the Guinea Coast of West Africa from the 1600s to the early 1900s. Such bars were cut up and forged by African blacksmiths into farm tools and weapons for hunting and warfare. The bar also became a standard of value by which other goods, including enslaved people, were priced.
Modern copy made in 2007.
Plymouth City Museum and Art Gallery.

Manilla
Copper and brass manillas were made by the million in many parts of England between the 1600's and the late 1800s, exclusively for the West African market. Most were used as currency by English slave traders to buy enslaved Africans and other goods. When manillas were abolished as currency in south-east Nigeria in 1948, over 32 million were handed in to the authorities.
18th century.
Plymouth City Museum and Art Gallery.
See p. 75

Glass beads
These glass beads were acquired in West Africa, having been made in Venice or Bohemia and used by European and African traders as currency to buy many kinds of commodities, including enslaved Africans.
18th century.
Plymouth City Museum and Art Gallery.

Copper currency
Copper rods, made in England, collected in Nigeria in about 1904. They were used as currency and as a standard of value in this part of West Africa.
19th century.
Plymouth City Museum and Art Gallery.

Cowries (*Cypraea moneta*).
These shells were used as small change in many parts of West Africa for at least 1000 years. The molluscs that produced them live in the Indian ocean.
Before 1900.
Plymouth City Museum and Art Gallery.

Gold
Sample of gold in a lump of quartz. Gold has been mined in what is now Ghana for hundreds of years. Stories of the wealth of the "Gold Coast" first drew Europeans to the coast of West Africa in the 1400s.
20th century.
Plymouth City Museum and Art Gallery.

Ivory
Carved ivory, made from the tusk of a West African elephant. Enslaved Africans, gold and ivory were the most important commodities obtained by Europeans from West Africa.
Early 1900s.
Plymouth City Museum and Art Gallery.

Leg shackles
Iron, used on Africans in slave ships in 19th century.
Mid 19th century.
Plymouth City Museum and Art Gallery.
Chosen by Raimi Gbadamosi.

Dogfish, a kind of shark.
Sharks followed ships used in the slave trade across the Atlantic, attracted by the ships' smell and the likelihood of dead or dying captive Africans being thrown overboard.
Late 19th century.
Plymouth City Museum and Art Gallery.
Chosen by Raimi Gbadamosi.

Slave Trading Links with Plymouth and Devon

Hieronymus Custodis
Admiral Sir John Hawkins (1532-1595)
Oil on panel.
1591.
Plymouth City Museum and Art Gallery
See p. 20

Attributed to Marcus Gheerhaerts the Younger
Sir Francis Drake (1532-1595)
Oil on canvas.
Late 16th century.
Plymouth City Museum and Art Gallery
See p. 22

Willem van de Velde the Younger
View of Plymouth Sound and the Citadel from around Jennycliffe
Oil on canvas.
About 1673-75
Plymouth City Museum and Art Gallery
See p. 45

Slavery and the British Way of Life

Fragments of moulds
Earthenware moulds used in making sugar cones or loaves. They were manufactured in Spain and found during excavations at Plymouth's town tip in Castle Street which is dated to between 1660 and 1700. They show that sugar from plantations in the West Indies was being refined in Plymouth at this time.
Mid 17th century.
Plymouth City Museum and Art Gallery

Fragments of moulds and other vessels used in sugar refining
These were excavated in Goldsmith Street, Exeter and are dated to between 1680-1720. At this period, Exeter was third only to Bristol and Liverpool in trade with the plantations.
1680-1720.
Royal Albert Memorial Museum & Art Gallery, Exeter.

Copies of sugar loaf, sugar refining mould and vessels
Earthenware, 17th century and modern.
Royal Albert Memorial Museum & Art Gallery, Exeter.
See p. 85

Mug, Jug, Sauceboat
Porcelain, made in Plymouth. by Cookworthy
1768-1770.
Caddy spoon. Silver. English.
1820.
Teapot. Porcelain. Sèvres.
1763.

Teacup and saucer. Porcelain. Sèvres.
1763.
Tea caddy. Porcelain. Meissen. About 1760.
Coffee pot. Silver. Pentecost Symons: Exeter.
1739-1740.
Sugar caster. Silver. Samuel Wood, London.
1742.
See p. 74
Milk jug. Porcelain. Bristol.
1770-1781.
Chocolate cups. Porcelain. Meissen.
1730-1740.
Chocolate pot. Porcelain. Plymouth.
1768-1770.
Teaspoons. Silver. English.
1760-1790.
Rummers. Glass. English.
1740-1780.
Decanter. Glass. English.
1750-1790.
All typical of an 18th century table setting for a middle class family.
Plymouth City Museum and Art Gallery
Chosen by Raimi Gbadamosi.

Snuff box. Silver gilt. French.
1740-1780.
Snuff box. Silver. English.
1750-1790.
Snuff box. Silver. Birmingham.
1828.
Two snuff boxes.
Wood, English.
19th century.
Plymouth City Museum and Art Gallery
Chosen by Raimi Gbadamosi.

Tobacco pipes
Fragments of clay pipes excavated in Plymouth; mostly 17th or 18th century.
Plymouth City Museum and Art Gallery:
Chosen by Raimi Gbadamosi.

Cocoa pod and solids, chocolate, cotton, various tropical woods.
Samples of commodities produced through the plantation system.
18th century.

Plymouth City Museum and Art Gallery and The Eden Project.

The 'Four Continents': Africa, Asia, America, Europe
Figures. Porcelain. Plymouth.
1768-1770.
Plymouth City Museum and Art Gallery:
Chosen by Raimi Gbadamosi.

Copy of the Gentleman's Magazine
Showing cameos of two visiting black celebrities, Job Ben Solomon and William Ansah Sessarakoo, both sons of distinguished Africans, who had been sold into slavery.
20th June 1750.
National Portrait Gallery, London.
See p. 54

John Faber Jnr.
William Ansah Sessarakoo
Sessarakoo was the son of a wealthy African slave-trading family who left his home on the Gold Coast, in modern-day Ghana, to become educated in the English ways of doing business so that he could act as a middleman for his father's successful trading company. Instead of taking him to England, the Captain of the ship on which he was travelling sold him into slavery. He was freed by the Earl of Halifax and eventually arrived in England in 1749 where he was feted as a celebrity and believed to be a prince.
Mezzotint
1750
National Portrait Gallery, London.

Benjamin Robert Haydon
An Unexpected Visitor
Oil on canvas.
About 1810
Plymouth City Museum and Art Gallery
Chosen by Raimi Gbadamosi.
See p. 73

Striving Towards Abolition

A Collection of Advices by the Yearly Meeting in London
Kept by the West Devon Meeting of the Society of Friends in Plymouth. The first statement of antipathy to the Transatlantic Slave Trade was expressed in 1727: "It is the sense of this meeting that the Importing of Negroes from their Native Country & Relations by Friends is not a commendable or allowed Practice & the Practice is censured by this meeting".
Manuscript.
1721–1761.
Plymouth & West Devon Record Office.

Francesco Bartolozzi after Gainsborough.
Ignatius Sancho (1729-1780)
Sancho was born on a slave ship in the mid-Atlantic. He was given to three sisters in Greenwich but ran away and became butler to the Duke and Duchess of Montagu. Here he indulged his passion for reading and writing. He was welcomed by London's literary and artistic set, and was painted by Thomas Gainsborough. In 1773 he opened a grocery shop in Westminster with a legacy from the Duchess. He became the first African prose writer published in England. His Letters, released in 1782, were an immediate best seller.
Engraving
1768 (published 1802)
National Portrait Gallery, London.

Daniel Orme after an original by W. Denton.
Olaudah Equiano (about 1745-1797)
Equiano was a celebrated anti-slavery campaigner. In 1789 he published *The Interesting Narrative of the Life of Olaudah Equiano, or Gustavus Vassa, The African*, one of the most important publications of the abolition movement.

He worked in Plymouth in 1787 as Commissary for the ships taking recently freed Africans to Sierra Leone.
Engraving
1789
National Portrait Gallery, London.
See p. 62

Alfred Edward Chalon
Thomas Clarkson (1760-1846)
Now recognised as one of the most important abolitionists in England, Clarkson rode thousands of miles across the nation to gather support for the Abolition Committee, founded in London in 1787. While on these public tours he took a box of African trading goods. He used these to illustrate the skills of Africans, but also included the instruments of punishment and enslavement, such as collars, chains and shackles. These were often made in Britain. Clarkson visited Exeter and Plymouth in 1788 and 1790 to speak at public meetings and collect information.
Mezzotint
1824
National Portrait Gallery, London.
See p. 61

Francesco Bartolozzi, after Reynolds
William Murray, 1st Earl of Mansfield
Lord Mansfield's judgement in the case of James Somersett stated: 'No master was ever allowed...to take a slave... by force to be sold abroad'. He did not outlaw slavery in England; indeed Mansfield himself opposed the immediate abolition of slavery. However, his judgement assisted the abolitionist cause.
Engraving
1786
National Portrait Gallery, London.
See p. 58

Plan of an African Ship's lower deck with Negroes in the proportion of only One to a Ton

Part of a pamphlet published by Plymouth Committee for Abolition of the Slave Trade in December 1788. The plan was drawn to illustrate how much space 295 people would take up on the deck of the Brookes, a Liverpool slave ship. 295 was the legal limit, based on the figure of one person per ton of ship, as specified in the Dolben Act of 1788.
1788
Print
Bristol Record Office.
See p. 63

François Séraphin Delpech
Toussaint L'Ouverture (1746-1803)
L'Ouverture led the Haitian Revolution, the massive slave uprising that erupted in 1791. He invoked the French Revolutionary principles of liberty and equality for the enslaved peoples of the Colony. L'Ouverture was eventually arrested by his French adversaries and, under the orders of Napoleon Bonaparte, was killed through ill treatment and starvation. However, his followers continued to fight and declared the island an independent republic in 1804.
Lithograph.
Early 19th century.
National Portrait Gallery, London.
See p. 66

After George Romney
John Wesley (1703-1791)
Founder of the Methodist movement. A tireless traveller, preacher and writer, Wesley averaged 8,000 miles a year on horseback and gave 15 sermons a week.
In March 1788 Wesley delivered one of his most famous sermons on the immorality of the slave trade in the New Rooms, Bristol. He believed that the nation's greatest crime was its trade in enslaved peoples. Wesley read Olaudah Equiano's *The Interesting Narrative* while on his deathbed and it is said to be the last secular book that he read.

Oil
1789
National Portrait Gallery, London.

William Say
Samuel Taylor Coleridge (1772-1834)
Coleridge was born in Ottery St Mary, Devon. As a young man, he delivered lectures on religion and slave trade in Bristol in 1795.
Mezzotint
Published November 1840
National Portrait Gallery, London.
See p. 67

After watercolour by George Richmond
William Wilberforce (1759-1833)
An evangelical Christian and social reformer, Wilberforce dedicated himself to the 'suppression of the Slave Trade and the reformation of manners'. He entered Parliament in 1780 as a Tory MP and was the Parliamentary leader of the Abolition movement from 1787. After years of campaigning, Wilberforce's bill to end Britain's part in slave trading was passed to a standing ovation in 1807. A further act of 1833 provided for the emancipation of slaves in British colonies.
Print, 1833
National Portrait Gallery, London.
See p. 64

1807 and after, in Britain and the Americas

Posters
Published in Plymouth between 1814 and 1828 advertising meetings to request petitions to Parliament to bring to an end various forms of slavery and the slave trade.
1814-1828.
Plymouth & West Devon Record Office.

Medal
Struck to commemorate the 1807 Act: "We are all Brethren. Slave Trade Abolished by Great Britain 1807", Arabic script on

reverse. 50,000 of these were struck by the Soho Mint in Birmingham in 1814 for use in Sierra Leone.
Copper alloy.
1814
Torquay Museum.

Medal
Struck to support the involvement of women in the anti-slavery movement of the 1820s: "AM I NOT A WOMAN AND A SISTER?"; "To the Friends of Justice Mercy & Freedom" on the reverse.
Copper alloy.
1820s
Torquay Museum.
See p. 75

Necklace and earrings
Typical of the sort of jewellery that a woman in support of Abolition would wear. Studded with cameos depicting heads of African slaves, this jewellery would have acted as a visual reminder of the slave trade and its appalling conditions. Wearing this necklace would be seen as a public sign of support for the Abolitionist movement.
Gold.
Early 19th century
Private collection

Thomas Phillips
William Blake (1757-1827)
Blake was an engraver who felt he had a calling as a divinely inspired poet and prophet. He developed an integrated method of engraving copper plates with words and images. His visionary illuminated works include *Visions of the Daughters of Albion* (1793) and *Songs of Innocence and Experience* (1794). He spoke out against the slave trade.
Oil
1807.
National Portrait Gallery, London.

Augustin Edouart
Hannah More (1745-1833)
Brought up in Bristol, More became a fashionable playwright, before turning to the

serious work of an evangelical reformer. From the 1780s, she wrote numerous treatises attacking moral laxity, fashion and female independence. Most influential were her 'Cheap Repository Tracts', which sold for a penny and reached millions. She spoke out against the Slave Trade in poems such as *The Negro Woman's Lamentation*, which were widely read.
Silhouette
1827
National Portrait Gallery, London.

Tea cup
Commemorative, to promote continuing anti-slavery work in the 1840s. " 'Take courage-go on, persevere to the last' Thomas Clarkson Age 81"
Porcelain
1840's
British Empire & Commonwealth Museum, Bristol

John Alfred Vinter, after Benjamin Robert Haydon
The Abolition of the Slave Trade (The Anti-Slavery Society Convention, 1840)
In 1787 a small, mainly Quaker group led by Thomas Clarkson formed The Society for the Abolition of the Slave Trade. The Great Reform Act of 1832 swept away many of the old pro-slavery MPs and the emancipation of slaves in British colonies was effected by the Act of 1833.
Lithograph
1841
National Portrait Gallery, London.

Artist unknown
Heroes of the Slave Trade Abolition (Granville Sharp; Zachary Macaulay; William Wilberforce; Sir Thomas Fowell Buxton; Thomas Clarkson)
Through the spread of popular engravings such this, the faces of the anti-slavery leaders became well known .The product of an energetic propaganda campaign, they celebrated the achievements of the movement celebrating Britain's lead in the struggle for future generations.
Wood engraving
Date unknown
National Portrait Gallery, London.

Harp-lute
This type of instrument originated from what is now Southern Sierra Leone, and is similar to the West African *kora*. It is as yet not known how this example came to be in South America, but its presence there strongly suggests the continuity of African musical traditions by supposedly enslaved people.
Collected in Cartagena, Colombia, before 1865.
Royal Albert Memorial Museum & Art Gallery, Exeter.
See p. 86

Glazed earthenware figure of Uncle Tom & Eva
Made in Staffordshire. The book *Uncle Tom's Cabin*, by Harriet Beecher Stowe, was first published in 1860. The story of slavery in the American south told from a slave's viewpoint, was a great success. It contributed to the outbreak of the American Civil War in 1865. These figures were made in large numbers to take advantage of the book's success.
About 1875
Plymouth City Museum and Art Gallery

Patrolling the Seas

Instructions for the Guidance of Her Majesty's Naval Officers Employed in Suppression of the Slave Trade
First issued in 1844, the volume was compiled largely by Captain Joseph Denman. It was the standard practical handbook, essential in gathering evidence about slaving activity on the high seas in order to obtain successful court prosecutions.
1895 edition
Trustees of the Royal Naval Museum, Portsmouth.

HM Brig Acorn, 16 guns in chase of the piratical slaver Gabriel, 1841
The *Acorn* sailed from Plymouth in 1839 on anti-slavery operations. She captured a Spanish slaver on 6 July 1841.
Print
British Empire & Commonwealth Museum, Bristol.
See p. 82

Two images of emancipadoes (freed slaves)
One shows them in negotiation with a white man. It is likely that this is taking place at Plymouth, Montserrat, in the West Indies. This is an idealised version of the consequences of emancipation. *Emancipadoes* rarely obtained their freedom without a struggle.
Print
Date unknown, about 1840s
Plymouth & West Devon Record Office.

Decorated gourd container
Geometric and figure designs, showing people and animals, probably a hunting party. It was obtained by Lt W.R. Bent while he was working on HMS Vengeance, a slavery patrol ship out of Lagos Nigeria, in 1851-52.
Made before 1852
Royal Albert Memorial Museum & Art Gallery, Exeter.

Wood staff
In the form of a double-headed axe, with a kneeling female figure wearing beaded jewellery. This form of staff is associated with followers of Shango the Yoruba god of thunder. It was obtained by Lt W.R. Bent while he was working on HMS Vengeance, a slavery patrol ship out of Lagos Nigeria, in 1851-52.
Made before 1852
Royal Albert Memorial Museum & Art Gallery, Exeter.
See p. 85

Legacies of the Trade in Africa

Bracelet
Ivory, carved into two interlocking sleeves. Probably taken from Benin City, Nigeria, as a result of the British Punitive Expedition in 1897.
18th century
Plymouth City Museum and Art Gallery

Figure of an Oba, or King of Benin
Part of a ceremonial staff. Probably taken at the time of the Punitive Expedition to Benin City in 1897.
18th century
Royal Albert Memorial Museum & Art Gallery, Exeter.

Commemorative head
Copper alloy, made at the command of a new Oba, or King of Benin, for an altar dedicated to his predecessor. This was taken by Ralph Locke during the British Punitive Expedition to Benin City in 1897.
Early 19th century
Royal Albert Memorial Museum & Art Gallery, Exeter.
See p. 83

Flintlock blunderbuss
Collected by Ralph Locke from a canoe operating in the estuary of the River Niger at the time of the British Punitive Expedition to Benin City, February 1897.
Mid 18th century
Royal Albert Memorial Museum & Art Gallery, Exeter.

Writing board
Wood, obtained by Lt W.R. Bent probably in Lagos 1851-52, in Nigeria, whilst he was working on HMS Vengeance, a slavery patrol ship. Used by students of the Qur'an.
Made before 1852.
Royal Albert Memorial Museum & Art Gallery, Exeter.

Figure of Eshu, the Yoruba trickster deity
Carved wood figure, holding a staff in the form of a flute, and wearing an elaborate female hairstyle. One of a pair of figures given to Revd Henry Townsend by Ogunbona, a senior chief of Abeokuta, Nigeria. Townsend was a Christian missionary in

Abeokuta between 1843-1876.
Made before 1868
Royal Albert Memorial Museum
& Art Gallery, Exeter.
See p. 88

Necklace
Made of flat discs carved from
kernels of the oil-palm. It was
obtained by Revd Townsend
in Abeokuta, Nigeria, between
1843 and 1868. Palm oil was a
major international cash crop for
the farmers of Abeokuta. It was
exported in great quantities to
Europe for use as a raw material
in the manufacture of soap and
margarine.
Made before 1868
Royal Albert Memorial Museum
& Art Gallery, Exeter.

Container with close fitting lid
A kneeling female figure on
a globe; probably used by a
follower of Shango the Yoruba
god of thunder. It was obtained
by Revd Townsend in Abeokuta
between 1843 - 1868.
Made before 1868
Royal Albert Memorial Museum
& Art Gallery, Exeter.

Mask
Wood, Depicting a mother
with children. It was worn by a
dancer as part of the activities
associated with the annual Epa
ceremonies of regeneration.
It was taken from Eruku, in the
Yagba state, north-eastern
Yoruba region of Nigeria in 1899,
by officers of the Royal Niger
Company.
Made before 1899
Royal Albert Memorial Museum
& Art Gallery, Exeter.

Figure
Wood, representing the guardian
of one of the gates of the Yoruba
town of Meko, Nigeria. It was
removed by R.B.Newberry, an
Education Officer in the Nigerian
Civil Service, between 1922
-1948. He justified removing it
by saying he thought it was out
of use, as no offerings had been
placed before it.
Made before 1948
Royal Albert Memorial Museum

& Art Gallery, Exeter.

Ifa board
Wood, used in the Yoruba
system of divination, called Ifa. It
was obtained by John Stephens,
while he was working in Nigeria
in the 1910s, probably as a
missionary.
Made before about 1915
Royal Albert Memorial Museum
& Art Gallery, Exeter.

Fly whisk
Wood covered in beadwork.
Possibly used by an Ifa
divination priest. It was collected
by Francis Pinkett, a Colonial
Administrator in the south-west
Yoruba area of Nigeria, between
1900 and 1910.
Made before 1910
Royal Albert Memorial Museum
& Art Gallery, Exeter.

Game board
Carved and painted wood board,
used for playing a game with
seeds called Ayo. The carving
is unusually elaborate, showing
craftspeople, dancers and
musicians. It was collected by
C.H. Mitchell in the early 1900s.
Made before about 1905
Plymouth City Museum and Art
Gallery

Short sword
The blade is probably made
from local iron. Collected from
the Calabar area of south-east
Nigeria.
Made before 1846
Royal Albert Memorial Museum
& Art Gallery, Exeter.

Model canoe
Wood, of a type that traded
along the creeks of the
Cameroon River, south-east
Nigeria.
Made before 1860
Royal Albert Memorial Museum
& Art Gallery, Exeter.

Fan
Wood, carved with designs
typical of the Ibibio communities
from the trading town of Old
Calabar, south-east Nigeria. It
was collected by the Revd Henry

Townsend in 1860s.
Made before 1868
Royal Albert Memorial Museum
& Art Gallery, Exeter.

Musical instrument
A type called an 'mbira', played
by plucking the bamboo tongues
using the thumbs. It is decorated
with designs distinctive of the
Ibibio communities from the
trading town of Old Calabar,
south-east Nigeria. Collected
in 1880s.
Made before about 1885
Royal Albert Memorial Museum
& Art Gallery, Exeter.

Umbrella
Covering of silk damask,
presented to the Sirikin (chief)
of Abuja in Northern Nigeria by
the Royal Niger Company. It was
taken by Lt Pye while he was
in action with the West Africa
Frontier Force in 1902.
Made before 1902
Plymouth City Museum and Art
Gallery.
See p. 91

Robe
Cotton, with protective amulets,
worn by a man. It was taken by
Lt Pye while he was in action
with the West Africa Frontier
Force in 1902.
Made before 1902
Plymouth City Museum and Art
Gallery.
See p. 98

Saddle cloth
Made of imported woollen
cloth, locally-made cotton, with
leather applied patterns. Worn
over a saddle for use on special
occasions. It was taken by Lt
Pye while he was in action for
the West Africa Frontier Force
in 1902.
Made before 1902
Plymouth City Museum and Art
Gallery.

Horse bridle
Leather remains of woollen cloth
cover, with tin rattles, used on
special occasions. It was taken
by Lt Pye while he was in action
for the West Africa Frontier

Force in 1902.
Made before 1902
Plymouth City Museum and Art
Gallery.

Smoking-pipe bowl
Earthenware bird with
backward-turned head
signifying the message 'do
not forget tradition'. This was
collected in the Asante capital
of Kumasi.
Made before 1883
Royal Albert Memorial Museum
& Art Gallery, Exeter.

Stool
Wood, brought back from
Kumasi by a journalist, Mr
Kinnear, who was working for
the Western Morning News
covering the British attack on
Kumasi early in 1896. The stool
shows signs of having been
used and washed many times
over a long period of time,
so was made much earlier in
the 19th century. It may have
been owned by the head of an
Asante household in Kumasi.
Most houses in the capital were
burned down by British forces
during the attack.
Mid 19th century
Plymouth City Museum and Art
Gallery.
See p. 75

Weights
Copper alloy, used in southern
Ghana to weigh gold dust, the
currency of the Akan peoples
until the end of the 19th century.
Obtained by Gertrude Benham
in the 1920s.
Made from 17th to mid 19th
centuries
Plymouth City Museum and Art
Gallery.
See p. 74

Two female figures
Wood, used in divination by
female diviners of the Mende
and Sherbro communities in
southern Sierra Leone. They
were collected by C.H. Mitchell
in the early 1900s.
Made about 1905
Plymouth City Museum and Art
Gallery. See p. 76

Mask
Wood, part of the costume worn
by the leader of the female
Sande society. Sande lodges
exist in each Mende village to
educate girls. It was collected by
C.H. Mitchell in the early 1900s.
Made about 1905
Plymouth City Museum and Art
Gallery.

Ceremonial fly whisk
Wood, leather, beads, used in
dances by Mende diviners in
Sierra Leone. It was collected by
C.H. Mitchell in the early 1900s.
Made about 1905
Plymouth City Museum and Art
Gallery.

Figure group
Painted wood, made to satirise
the activities of Europeans by a
Bakongo carver probably from
the western part of what is now
the Democratic Republic of the
Congo.
Made before about 1905
Plymouth City Museum and Art
Gallery.
See p. 29

Male power figures
The glass-fronted box contains
medicinal substances. These
figures were used by priests in
BaKongo villages to activate
spiritual forces on behalf of
villagers. They were collected in
the 1870s and 1880s by Dennett
while working as a trader in
Cabinda, Central Africa.
Made before 1885
Royal Albert Memorial Museum
& Art Gallery, Exeter.

Legacies of the Trade Today

Specimen of diamond
13.64 carats. Africa is a major
producer of diamonds, both
in volume and in value. In the
late 19th century, many local
Africans travelled from as far
as 70km to work for the new
industry, owned by Englishmen;
meticulously sieving river
sediments and even crawling
on hands and knees looking for
diamonds in coastal sands in
Namibia. This specimen is from

Kimberly Mines in South Africa.
It is rare to be found in its natural
form as an octahedron.
Plymouth City Museum and Art
Gallery.
Chosen by Raimi Gbadamosi.

Specimen of gold
from Sheba Transvaal, South
Africa.
Plymouth City Museum and Art
Gallery.
Chosen by Raimi Gbadamosi.

Specimens of Cassiterite
(tin ore)
In the early 20th century, Nigeria
was one of the world leaders in
the production of tin and still
produces tonnes of tin today.
The tin is mined or sieved from
rivers on the Jos Plateau,.
One of the pieces contains a
white sapphire.
Plymouth City Museum and Art
Gallery.
Chosen by Raimi Gbadamosi.

Biographies

Jyll Bradley was born in Folkestone, UK and lives and works in London. She studied at Goldsmiths College and the Slade School of Fine Art, London. Recent solo exhibitions include Newlyn Art Gallery/The Exchange (2010) and the Walker Art Gallery, Liverpool where she undertook a major project as part of European Capital of Culture 2008. Bradley has participated in numerous group exhibitions including the Calouste Gulbenkian Foundation, London (2009); Arnolfini, Bristol (2005); Spacex, Exeter (2004); Hayward Gallery, London *The British Art Show* (1990); and Maureen Paley Interim Art (1989).

Her work has been exhibited internationally; solo projects include Museo D'Antioquia, Medellin, Colombia, and Vitamin Creative Space, Guangzhou, China (2004). Forthcoming solo projects include *Airports for the lights, shadows and particles* at the Bluecoat, Liverpool (2011). She recently undertook a residency in the Galapagos Islands, as part of *Darwin 200,* to produce work for an exhibition at the Calouste Gulbenkian Foundation, Lisbon (2012) and is developing a commission in Canberra, Australia to be presented as part of the city's centenary (2013). www.jyllbradley.net

Lisa Cheung was born in Hong Kong, grew up in Toronto, and returned to Hong Kong before relocating to London to study for an MA in Fine Art at Goldsmiths College. She lives and works in London and Granada, Spain. Commissioned projects include *Mobile Allotment* (London, 2009 and onwards) supported by Arts Council England and UnLtd Awards, *Huert-o-bus,* Madrid Abierto (Madrid, 2010), and *Velo-Rel-La*, Radar Arts Programme, Loughborough University (Loughborough, UK, 2009).

She has exhibited extensively in the UK including at Tatton Park Biennial (2008), Aspex Gallery (Portsmouth, 2007), and A Foundation (Liverpool, 2007) as well as internationally in Madrid, Seoul and Toronto. She has participated in many artist-in-residency programmes including Camden Arts Centre, London (2002), Rio de Janeiro as part of the Triangle Arts Exchange (2003), and Acme Firestation Studios, London (2005-2010). www.lisacheung.com

Liam Connell teaches English at the University of Winchester, UK. He has published on globalisation and culture in the journal *Critical Survey* (2004), in the collections *Globalization and its Discontents* (2006) and *Global Babel* (2007). He is also co-editor of *Literature and Globalization: A Reader* (2010). His current research is on the representation of labour in contemporary fiction including a collaborative project on the offshore as a cultural idea.

Tony Eccles was born in Liverpool. Formerly of the World Museum, Liverpool, he is currently the Curator of Ethnography at the Royal Albert Memorial Museum in Exeter (RAMM), UK. Since the Museum's refurbishment programme began in 2007, he has been engaged in projects designed to create access to the Designated ethnographic collection. In addition to *Human Cargo*, projects include Beauty – In the *Eye of the Beholder?* at Museum in the Park, Stroud, UK, *Token Values* at the Devon Guild of Craftsmen, Bovey Tracey, UK and *Small World*, a school-based project that addresses identity through fashion. He is currently planning new content for the World Cultures galleries for the Museum's re-opening in 2012.

Kodzo Gavua is former Head of the Department of Archaeology and Heritage Studies at the University of Ghana and a cultural activist. His research interests are Globalization and Cultural Change in Ghana and his current research focuses on the Internal African Diaspora in Ghana as well as Religion and Identity in the Volta Region of Ghana. He is National Coordinator, British Museum projects in Ghana; Member, Council of the University of Ghana; President, University of Ghana branch of the University Teachers Association of Ghana. In November 2010, he was elected a Vice-President of the Pan African Archaeologists Association. He received a Ph.D in Archaeology from the University of Calgary, Canada, and an MA in International Affairs from the University of Ghana.

Raimi Gbadamosi was born in Manchester, UK and lives and works in London. He is an artist, writer and curator. He received his Ph.D in Fine Art from the Slade School of Fine Art, London, and is a member of the Interdisciplinary Research Group *Afroeuropeans*, University of Leon, Spain, and the 'Black Body' group, Goldsmiths College, London. He is also on the Editorial board of Third Text. Recent national and international exhibitions and events include *Exchange Mechanism, Belfast* (2010); ARCO Madrid (2009); *Tentativa De Agotar Un Lugar Africano*, CASM, Barcelona (2008); Port City, Arnolfini, Bristol, UK (2007).

Work media include multiples, music, websites, writing and audience participation. His works seek to create debate, instead of representing preconceived concerns defined by specific social, cultural and political cant. Books include *incredulous; ordinary people; extraordinary people; contents; Drink Horizontal; Drink Vertical; The Dreamers' Perambulator;* and *four word. The Republic*, an independent state, negotiates the meeting of language and social constructions. Essays include *The Not-So New Europeans*, Wasafiri UK, and *The Delight of Giant-Slayers: Or Can Artists Commit Their Lives to Paper?* ArtMonitor, Sweden. www.the-republic.net

Melanie Jackson was born in Hollywood, West Midlands, UK and lives and works in London. She studied at Byam Shaw College of Art and the Royal College of Art, London. She is a lecturer at the Slade School of Fine Art, London. Her work draws upon many different sources, drawn from a wide variety of international media outputs which are used as a catalyst for sculptures, films, animations, posters, pamphlets and maps.

Recent solo exhibitions include: *The Urpflanze (Part 1)* The Drawing Room, London (2010), *Road Angel*, Arnolfini, Bristol, UK (2006), and *Made In China*, Matt's Gallery, London (2005). Recent commissions include *International Fauna*, Relational, Bristol with Animate Projects, London and Picture This, Bristol (2010). She was shortlisted for the Whitechapel Gallery MaxMara Art Prize in 2008, and was winner of the Jerwood Drawing Prize in 2007. She was awarded an Arts Council Individual Artists Award in 2010. www.melaniejackson.net

Fiona Kam Meadley was born in Penang, Malaysia and lives and works in the England. She studied for an MA in Art, Media and Design at the University of West England where she researched into how visual culture can engage with peace building. She has been artist in residence at the Edward Jenner Museum, Peace Direct and Gloucestershire Assistance for Refugees and Asylum Seekers. Her films include *Testimony from Liberia* (screened at the ICA 2007), *Postcard from Penang* (East@West Wing 2007), and *Coast* (Elysium Artspace 2008). More recently she has been working on animation and graphic novels. She initiated the *War & Peace* project from 2005 to 2008 involving artist film makers and peace campaigners. She was a Development worker from 1986 to 2000 working in Africa with fair trade initiatives, micro finance and women's groups. www.fionakammeadley.info

Len Pole was born in London and lives and works in Essex, UK. He is a curator undertaking freelance contracts for several museums in UK to make better use of their world cultures collections. From 1996-2005, he developed new World Cultures galleries at Royal Albert Memorial Museum, Exeter and curated exhibitions featuring their internationally important collections. From 1974-1996 he managed the Saffron Walden Museum, Essex. He worked at the National Museum, Accra, Ghana from 1971-74, undertaking fieldwork in metalworking. From 1966-1971 he worked at the Horniman Museum, London. Publications include Second Skin (2004), Iwa L'Ewa – Yoruba & Benin collections in the Royal Albert Memorial Museum (1999), Saffron Walden in Old Photographs (1997), Worlds of Man: the ethnography collections at Saffron Walden Museum (1987), plus papers on African ironworking, Pacific Ethnography, and museological topics, from 1973.

Judith Robinson was born in Yorkshire and lives in Cornwall, UK. She is an art historian and museum curator and is currently Exhibitions Officer at Plymouth City Museum and Art Gallery. She established and lead the Human Cargo Project Team in 2006-7 and was project lead for the Sir Joshua Reynolds: The Acquisition of Genius exhibition in 2009. From 2000-2006 as Visual Arts and Media Officer with South West Arts and Visual Arts Officer at Arts Council England South West, she was responsible for curatorial practice, partnerships with the heritage sector and visual arts developments in Bath and Cornwall; including St Ives International, Newlyn Art Gallery and The Exchange in Penzance. From 1980-2001 she was based in Lincoln as a curator at the Usher Gallery, managing the fine and applied arts collections, and developing exhibitions and partnership projects; including, The Journey: A Search for the Role of Contemporary Art in Religious and Spiritual Life, co-curated with the artist, Garry Fabian-Miller in 1990, a multi-site project in sacred and secular sites in Lincoln Diocese; and Location + Poetry of Place, curated with the poet Thomas A. Clark in 1997. As a freelance lecturer and researcher, she has undertaken numerous projects, including a publication on the Duncan Grant Murals in Lincoln Cathedral in 2001.

Zoë Shearman is a contemporary art curator and writer based in Bristol, UK. As Director of Visual Arts, Riverside Studios, London (1990-1994) she curated the first UK survey exhibitions by Louise Bourgeois and Yoko Ono and toured work by Bill Viola internationally. In 1996, she co-curated the multi-site project The Visible and The Invisible, for the Institute of International Visual Arts (inIVA) London, including projects by Tania Bruguera, Doris Salcedo and Bruce Nauman. She has curated context-based projects for the Wellcome Trust, Camden Arts Center and the Freud Museum, London, amongst other organisations. As co-Director of Spacex, Exeter, UK (1999-2001) she curated projects by Angus Fairhurst, Christine + Irene Hohenbüchler, Sigalit Landau, Jayne Parker, Zineb Sedira and Lois + Franziska Weinberger. In 2001, she founded Relational a projects agency that places an emphasis upon context-based work. Curatorial projects include multi-site projects Patterns (2001) and Homeland (2004) with Spacex; Far West Metro (2008) and Craftivism (2009) with Arnolfini, Bristol; International Fauna (2010) by Melanie Jackson; and the Anti-Bodies programme (2009-12).
www.relational.org.uk

WESSIELING was born in Hong Kong and lives and works in London. She studied Fine Art at Central Saint Martins College of Art and Design, London. She is Senior Lecturer at the London College of Fashion. Her practice uses audio, text and installations to inquire into the immateriality of fashion and aestheticisation of everyday life. A case in point is how individuals exploit fashion and vice versa. The juxtaposition of its use and being used by it is a thread in her work. Recent exhibitions include Pitzhanger Manor Gallery and House, London (2010), MAK – Austrian Museum of Applied Arts / Contemporary Arts, Vienna (2007), Hong Kong Arts Centre (2007). Forthcoming exhibitions include the Brunei Gallery, SOAS, London (2012).
www.wessieling.com

Acknowledgements

Supported by
Arts Council England; Exeter City Council; the National Portrait Gallery through the Department for Culture Media and Sport/Department of Education (formerly known as the Department for Children, Schools and Families), National/ Regional Strategic Commissioning Partnership Programme; Plymouth City Council; and Royal Albert Memorial Museum & Art Gallery, Exeter, with support from the MLA's Designation Challenge Fund and the Renaissance in the Regions programme.

Exhibition Lenders
The Artists; British Empire & Commonwealth Museum, Bristol; The Eden Project; National Portrait Gallery, London; Plymouth City Museum and Art Gallery; Plymouth & West Devon Record Office; Royal Albert Memorial Museum & Art Gallery, Exeter; Royal Naval Museum, Portsmouth; Torquay Museum.

Thanks to
The Artists; the Human Cargo Project Team; Dave Atkin and the workers of ABP Port of Plymouth; John Allan; Arnolfini, Bristol; BBC South West; Jane Connarty; The Edith Freeman Day Centre; Fiona Evans; Barbara Farquharson and the Branscombe Project; The Friends of Plymouth Museum & Art Gallery; George Hadley and Claire Turner; Parliamentary Archives; Plymouth Arts Centre; Plymouth Central Library; Plymouth Centre for Faiths and Cultural Diversity; Plymouth and West Devon Racial Equality Council; Scope; Lee Sass, Shaun Standfield; The University of Plymouth; Dr. Bruce Wathen.

Photographic acknowledgements
All photographs are © the Artists/John Melville Photographer/Plymouth City Museum and Art Gallery unless otherwise stated. Pp 55, 57, Chris J. Bailey/Fiona Kam Meadley; p 25, Jyll Bradley; p 24, Jyll Bradley/George Hadley/Claire Turner; pp 83, 85, 86, 88, Dave Garner Photographer/Royal Albert Memorial Museum & Art Gallery, Exeter; pp 93, 96-7, 100, 101, Kodzo Gavua; pp 39, 66, 68, 69 70, 71, Raimi Gbadamosi; p 37, Raimi Gbadamosi/Alia Syed; p 36, Parliamentary Archives; p 75, Torquay Museum.

Timeline
Pp 80,90, Anti-Slavery International (http://www. antislavery.org); p 63, Bristol Record Office BRO17562; p 82, British Empire & Commonwealth Office; p 60, Museum of Fine Art Boston, USA; p 79, National Library of Jamaica; pp 21(L),37(L),56,58,61,62,64,66,67,94, National Portrait Gallery; pp 12,54, Len Pole; p 21(R), Plymouth City Library; pp 20,22(L),22(R),45(R),73,98,109, Plymouth City Museum and Art Gallery; p 45(L), Nigel Tattersfield; p 37(R) The Trustees of the British Museum.